THE ART OF
TASHA TUDOR

ALSO BY HARRY DAVIS

Tasha Tudor's Dollhouse: A Lifetime in Miniature

Forever Christmas

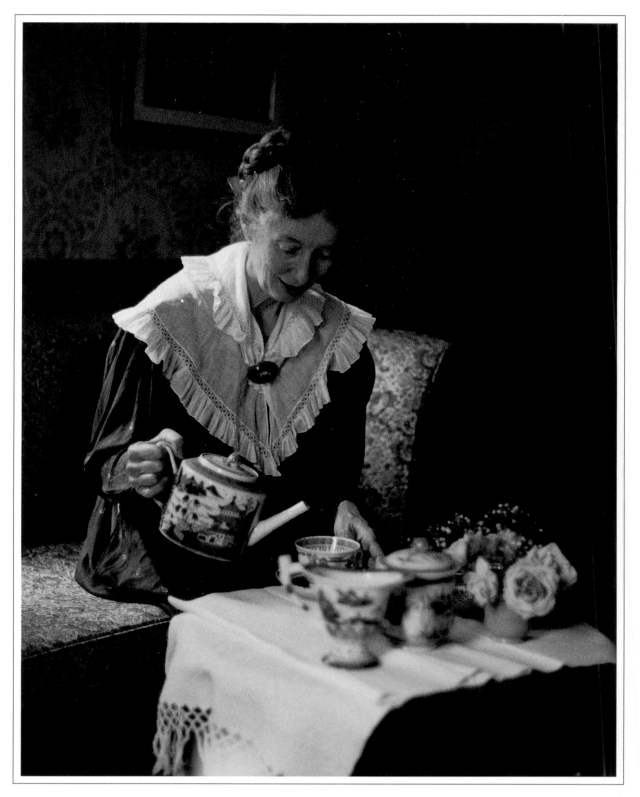

Tasha pouring afternoon tea, using antique Canton china brought back from China
as ballast in one of her great-grandfather Frederic Tudor's clipper ships.

THE ART OF
TASHA TUDOR

HARRY DAVIS

LITTLE, BROWN AND COMPANY

Boston New York London

First Edition

Library of Congress Cataloging-in-Publication Data

Davis, Harry.

The art of Tasha Tudor / Harry Davis.—1st ed.

p. cm.

Includes bibliographical references.

ISBN 0-316-17493-9 (hc)

1. Tudor, Tasha. 2. Illustrators—United States—Biography. I. Title.

NC975.5.T82 D38 2000

741.6'42'092—dc21

99-087687

10 9 8 7 6 5 4 3 2 1

Imago

Book design by Oksana Kushnir

Printed in Singapore

"Sometimes our inner light goes out, but it is blown again into flame by an encounter with another human being. Each of us owes the deepest thanks to those who have rekindled this inner light."

— Albert Schweitzer

THIS BOOK IS GRATEFULLY DEDICATED TO

Terry Buheller

Tom Kuhn

Bobbie Taylor

Gary Overmann

Lee Nichols

and, as always,

Jim Orum

CONTENTS

THE ART OF
TASHA TUDOR

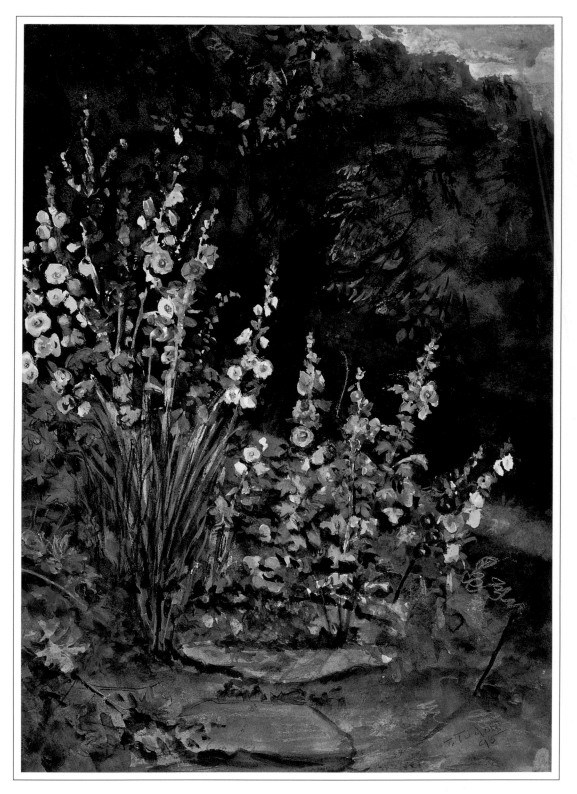

Tasha's Hollyhocks, 1995, published as a print, was done in a wet-paper technique
Tasha enjoys working with because of the challenge of painting before the paper dries.

INTRODUCTION

"The real point is not so much her art as the woman herself."

— *Philadelphia Inquirer*

It is almost impossible to separate Tasha Tudor's art from her life. Over the years, they have become virtually interchangeable. From childhood on, she has drawn and painted the people and scenes around her. As she has grown older and the tapestry of her life has become richer and more intricate, so has her art.

In one sense, all she has done is record the life going on around her. Major artistic legacies have often been created in this way. What is remarkable about Tasha's life, the one she has recorded in such abundant detail, is that the life itself is her greatest artistic creation. She refused to accept life as it came to her; she forced it, by dint of strong will and enormous imagination, to be exactly as she wished it to be. Having made fantasy real, she then painted it in a sensitive and delicate style and wove it into simple stories that have become a cherished part of the childhoods of millions of readers.

Largely self-taught, Tasha briefly attended the Boston Museum School of Art, but the greatest contribution to her skill as an artist has come from her consistently drawing in her sketchbooks,

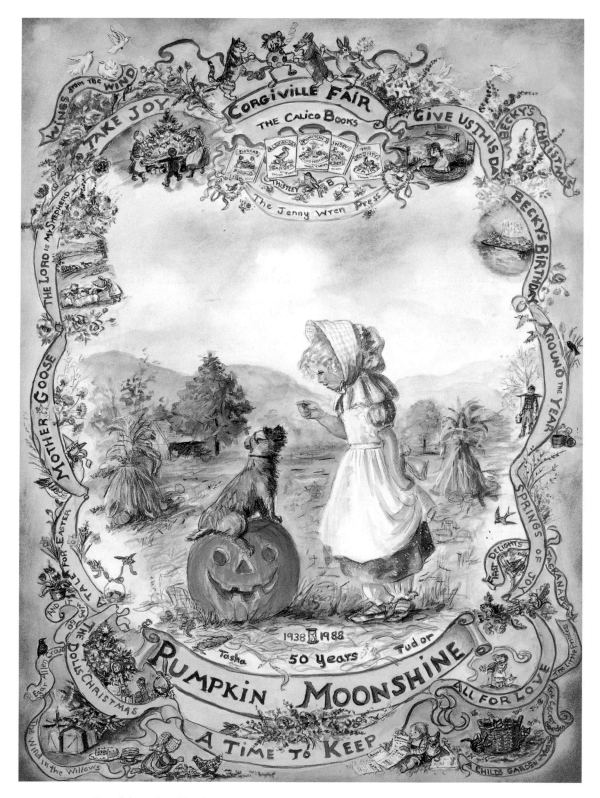

To celebrate her fiftieth anniversary as an illustrator (1938–88), Tasha produced this
poster, re-creating favorite scenes from many of her books.

almost daily, since an early age. Blank sketchbooks accompanied Tasha on all her trips, from child-hood visits to lengthy adult sojourns such as her stay in England in the 1950s. One interesting sketchbook from that period is filled with nude drawings and is all that remains of weekly art classes taken at the Kensington School of Art in London. Tasha destroyed all the larger pieces she did there, dismissing them as "too much trouble to pack."

Tasha Tudor has written, or illustrated, or been the subject of, more than ninety books during a career that has spanned almost three-quarters of a century. Along the way, she also created and lived the lifestyle pictured in those books, including raising her own food, spinning and weaving the material for her family's clothes, taking care of livestock, and bringing up four children by her-self. To earn extra money, she lectured and toured with elaborate marionette shows. One of her hobbies turned into the world's best collection of 1830s clothing; another became one of the finest cottage gardens in America.

These are only the extraordinary highlights of an extraordinary life. The books alone make her one of the more prolific illustrators of all time, but the output of other artwork is equally impres-sive. Tasha produced more than four hundred Christmas cards during the same period in which she was creating many of her books. She accepted commissions for portraits and product packaging and did fashion design for Pierre Deux. The list of her accomplishments is long and varied.

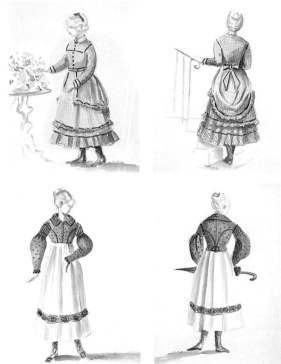

nterested in fashion since childhood, Tasha was inspired by clothing of the 1830s. As a teenager, she began assembling a collection from that period. She wore the antique pieces on special occasions and adapted the designs for everyday clothing that she made for herself. The collection evolved into the finest of its kind in the world, and Tasha has used it extensively in her illustrations as well as in fashion design. These designs were done for Pierre Deux.

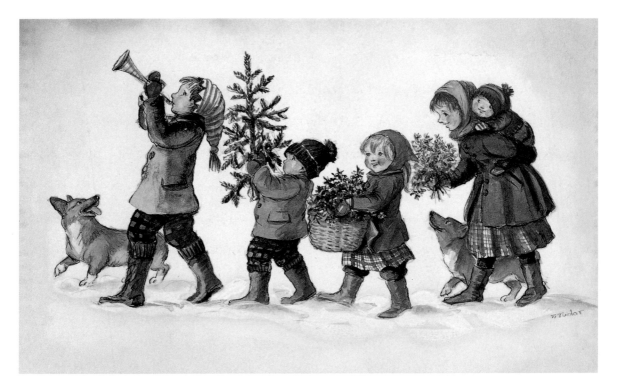

Children in the Snow, painted as a Christmas card in 1970; later published as a print. One of Tasha's quintessential images, this painting demonstrates how Tasha uses her children and grandchildren as models without regard to their relative ages. Son Seth leads the way, followed by son Tom, granddaughter Laura, Laura's mother, Bethany — depicted here as not much older than her daughter — and Bethany's sister, Efner. Tasha paints her family at the moment she remembers them at their best, mixing generations at will.

The appeal of both the woman and her art is undeniable. Her books have sold in the many millions. Her edition of *The Secret Garden* alone has sold over 3 million copies. As many as five generations of fans in a single family have shown up at public appearances to see the woman who has left an indelible imprint on the traditions and celebrations of fans all over the world. In addition to her fame as an artist, in recent years she has become a lifestyle icon. One of the more amusing and accurate descriptions of Tasha came from a reviewer who said that "she combines the fashion sense of Whistler's mother with the relentless industry of Martha Stewart."

At the core of all this admiration is a genius, with all the foibles of genius. She is notoriously slow-paced and something of a procrastinator, at least with commissioned or contractual art. She can be mean, stubborn, imperious, and unforgiving, by her own account. She often describes herself by quoting Mark Twain: "Everyone is like the moon and has a dark side which he never shows anybody." I have seen Tasha Tudor's dark side and it is, occasionally, frightening to behold. However, after more than a decade of being her friend, confidant, "favorite nephew," and business partner, I know nothing of Tasha Tudor's dark side that diminishes my respect or high regard for her and for the body of work she has created which constitutes such a magnificent legacy to the world.

The study of her art has fascinated me for more than thirty years. I learned to read using her books and, from a very early age, critiqued the illustrations in each book for my own amusement. I never questioned my obsession with her work, and since it was a quiet and untroublesome pursuit, neither did my parents. By the time I was a teenager, it was simply a part of my life — my job, as it were. I always knew that it would someday be my actual job, that I would come to know her personally and work with her. I continued my study of Tasha's art into adulthood, waiting for my opportunity.

While promoting a Christmas arts and crafts show to be held in Durham, North Carolina, I realized that the show needed something to give it additional appeal. I wrote Tasha and asked if she would come and speak at the show. She immediately said yes, and we corresponded for almost a year on the details. Close to the time of her appearance, Tasha requested that I call her. "It's time we talked," she wrote.

A pen-and-ink rendition of *Laura in the Snow*, Tasha's best-known painting, 1995, unpublished.

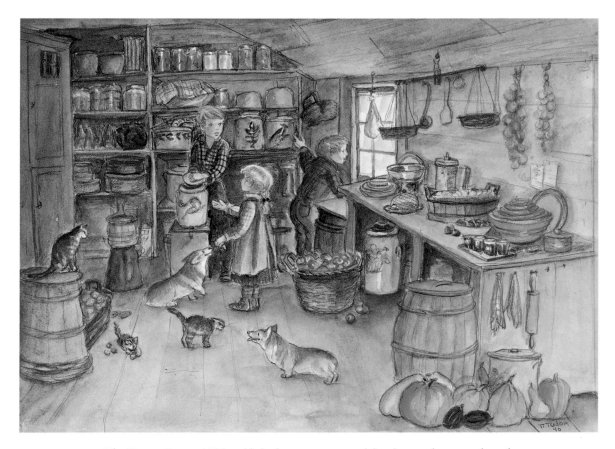

The Harvest Pantry, 1996, published as a print, exemplifies the storehouse quality of
Tasha's own ample pantry presented with all of her favorite kitchenware forming a
bountiful backdrop. Tasha's children — Seth, Tom, and Bethany — served as models
for this painting, done many decades since they were the age depicted.

I called her at the appointed time, knowing that a part of my life was going to change, to accel-
erate. Destiny had finally arrived. Tasha asked what room I was calling from, and I told her I was in
the kitchen. "Describe it," she directed. I did, and after a pause, she said, "You're describing *my*
kitchen." We were off and running. We would soon gleefully compete for the same antiques when
we traveled together, both of us being somewhat ruthless in the pursuit.

A few weeks after the show, several friends and I spent part of Christmas with her. Christmas
with Tasha Tudor! The magic became real. Other visits soon followed, and our friendship devel-
oped with the relaxed air of people who have known each other forever but have only just met. We

had many of the same interests — antiques, art, and literature. Our sense of humor was remarkably similar. I once overheard Tasha describing our relationship to someone: "Harry and I are cut from the same cloth. He's very wicked. And so am I."

Tasha gradually gave me certain projects to do for her. I reviewed contracts, offered suggestions on proposals, and frequently acted as a buffer between her and the world. If she were making a public appearance, say in Nashville or New York, I would accompany her whenever possible.

At one notable appearance in New York, sponsored by *Victoria* magazine but held at Bloomingdale's, we were truly overwhelmed. The public relations staff there had apparently prepared for five hundred people to attend a lecture by Tasha, but the publicity had been open-ended and extensive. They kept assuring us that space for five hundred fans would be "more than adequate. No more than that show up for anyone." They greatly underestimated Tasha's appeal. Three thousand people showed up, and we were faced with a dilemma. Tasha was opposed to turning away 2,500 people who had traveled from all over the country to see her. Thirty states were represented in the throng that overflowed throughout the store. She offered to give an abbreviated version of her talk, six of them, back-to-back.

Pansy in Canton, 1995,
published as a notecard.

Everyone was happy, but it took its toll on Tasha. She was exhausted at the end. When it was over, protected by security guards, we made a difficult exit. It was then that I knew my real job was about to begin. Tasha's popularity had increased to the point that she needed someone to coordinate her career and help her profit from many decades of work.

With the help of my friend Tom Kuhn, we formed a new partnership, Corgi Cottage Industries. Initially, our main concentration focused on producing prints and cards based on Tasha's art and made available to fans through a mail-order catalog. It was enthusiastically received and immediately successful. Tom soon left the company to go to medical school, his longtime dream, and Tasha and I got down to the serious business of promoting her.

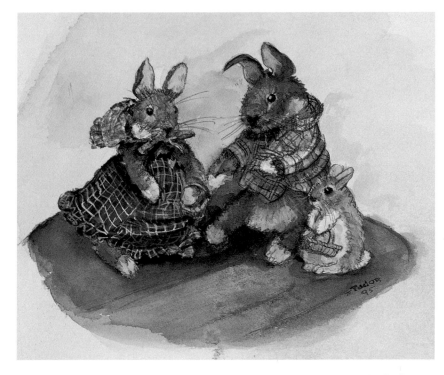

The O'Hare Family, p. 133, *Tasha Tudor's Heirloom Crafts*, 1995, later published as a print. This painting of a cut-wool family of rabbits — Woolsey, Letitia, and Tokki — made by Tasha, demonstrates her skill both as a toymaker and as an artist.

In the years that followed, we would bring four new books — two by Tasha and two by me — to publication. Reprints of more than a dozen of her out-of-print books would be arranged. Foreign editions of another dozen would be successfully negotiated. Two documentary videos would be filmed and distributed all over the world, and an impressive body of new art and original stuffed animals would be created. A blend of Tasha's own brand of tea, as well as face cream, would be marketed, and we licensed various companies to produce dolls, figurines, music boxes, cross-stitch kits, and a variety of other products.

Our greatest accomplishment was the landmark exhibition at the Abby Aldrich Rockefeller Folk Art Center in Williamsburg, Virginia, in 1996–97. *Take Joy! The World of Tasha Tudor* remains the most popular exhibition ever mounted there. The brochure proclaimed, "For sixty years Tasha Tudor's work has filled storybooks. Now it's filling a museum."

The exhibition was a fitting tribute to one of the century's most revered and beloved illustrators. Tasha herself was impressed at the scope and presentation of her life's work. Never confident about her accomplishments, she came to feel, at last, that she has indeed had a successful life. She mentioned several times how much she wished that her mother, father, and brother could have been there to see her work so honored. "They never thought anything would come of my art, you know." Although it was dismaying to realize that this world-renowned recipient of Caldecott Honors and the Regina Medal for Children's Literature had never considered herself a success, it was truly rewarding to see her so happy, finally at peace with the long struggle her life has been. In Tasha's typical way of making the world conform to her idea of how things should be, she will tell you, "My whole life has been a vacation." In truth, Tasha's life has been one of great effort and relentless work. She has taken pleasure in that work, but it was difficult nonetheless. Once, I asked Tasha to sum up her life in as few words as possible. "I was always tired," she said. The exhibition at Williamsburg gave validity to her art and her life.

I had realized from the beginning that our time together would be limited, but I also knew it would be one of the most interesting experiences of my life. It was something I had prepared for since childhood. It would last as long as it was supposed to, and when it ended, I would have no regrets.

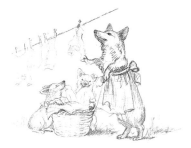

Mrs. B. Hanging Up the Wash. This pencil sketch, reminiscent of Corgiville, was the back-cover art for *Tasha Tudor's Sketchbook*, 1989.

Working with Tasha has been the magical ride of a lifetime. Every moment has been deliciously otherworldly, like her art. The art of Tasha Tudor is a remarkable body of work from a remarkable artist who has lived a remarkable life. We are all the beneficiaries of her artful living.

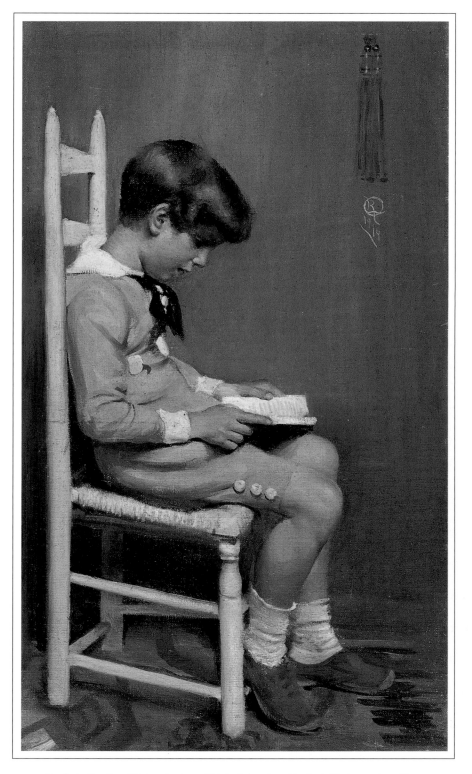

Frederic Reading. This painting of Tasha's brother, Frederic Tudor, painted by their mother in 1914, is an excellent example of Rosamond Tudor's skill as a portrait painter.

FAMILY

asha Tudor was born to parents whose families had occupied positions of wealth and influence for generations in Boston society. Her mother, Rosamond Tudor, was the granddaughter of Frederic Tudor, internationally known as the Ice King. He had amassed a sizable fortune by developing a way to ship New England ice to faraway places, including India and Persia. The family's friends down through the generations were accomplished and influential and included Ralph Waldo Emerson, Henry David Thoreau, Louisa May Alcott, Mark Twain, Oliver Wendell Holmes Jr., Alexander Graham Bell, Albert Einstein, and Buckminster Fuller. Frederic Tudor is referred to in Thoreau's *Walden* and was the inspiration for Amy's suitor in Loiusa May Alcott's *Little Women*.

The Tudors had been well connected for centuries. Tasha's great-great-grandfather Colonel William Tudor had been a friend and aide to George Washington and, along with Washington and Lafayette, had helped form the Society of the Cincinnati, the nation's oldest fraternal organiza-

Rosamond Tudor, Tasha's mother.

tion. He studied law under John Adams and served as the first judge advocate general of the United States.

An accomplished portrait painter, the highly individual and protofeminist Rosamond Tudor was evenly matched with Tasha's father, William Starling Burgess. Descended from a prominent and wealthy New England family, the Burgesses had lost their money, as had the Tudors, but the luster remained. A naval architect, Burgess designed three victorious America's Cup defenders. He was an important part of the early days of aviation and, with Buckminster Fuller, created the Dymaxion automobile. Although he had pursued yacht design as a profession, he also seemed to have seriously considered the life of a poet. His one published volume of poetry, *The Eternal Laughter and Other Poems,* while not popular with the public, received critical acclaim among fellow poets of his day.

The affair between Rosamond Tudor and Starling Burgess resulted in a scandal that rocked the foundations of proper Boston society. Burgess was still recovering from the recent suicide of his first wife, who had been found clutching a note to him that read, "You loved me once." Rosamond Tudor's husband, Alex Higginson, was not only wealthy and socially prominent, he was Starling's boyhood friend. In the two years preceding the affair, Starling had designed two sloops for Alex,

one of which, the *Outlook,* was the 1902 winner of the Quincy Yacht Club Challenge Cup. Starling and Alex's long personal and professional relationship made the divorce particularly nasty. To further complicate matters, Rosamond and Alex had a young son, Henry. The affair put their families, friends, and colleagues in a delicate position. At the height of the divorce proceedings, Starling left Boston to spend four months in England.

Starling and Rosamond were determined to be together and were quite willing to shock society and endure gossip and disapproval in order to do so. The process was emotionally draining as well as difficult to accomplish. Divorce was complicated and unpleasant at the turn of the century, but they persevered and were eventually able to marry. It is a further measure of the Tudor family's circle of acquaintances that Calvin Coolidge represented Rosamond in the divorce proceedings. When their marriage finally took place, in 1904, the *Boston Globe* called it "the most striking wedding of the year."

Together, they produced two sons, Edward and Frederic, but they were to lose Edward in a drowning accident, for which they both felt responsible. Left unsupervised on the deck of Starling's boat, which lay at anchor, Edward fell overboard, unnoticed by Rosamond and Starling, who were in their quarters below. The tragedy would eventually tear them apart, but the more immediate result was their decision to have another child, born on August 28, 1915, who was christened Starling Burgess but would grow up to become Tasha Tudor. "If Edward hadn't drowned," Tasha has observed, "I'd have never been born — Maman's doctors had warned her never to have another child." Tasha grew up keenly aware that her birth had been an attempt to replace her lost brother rather than the result of her parents' desire to have another child, and certainly not a daughter. The groundwork was unfortunately laid for lifelong feelings of insecurity and low self-esteem.

Her father was quite fond of Natasha, the heroine of Tolstoy's *War and Peace,* and he and Frederic held a second christening for his new daughter, renaming her. Natasha would soon be shortened to Tasha.

Tasha's parents divorced when she was nine, and she was sent to live with family friends, "Aunt Gwen" and "Uncle Michael," in Connecticut. Gwen Mikkelson was the granddaughter of Nathaniel Hawthorne, and she and her husband, Michael, shared an enormously creative, quite bohemian household. "I was brought up in complete sin," Tasha would say years later, with obvious relish.

Tasha would see her father only occasionally after the divorce. He would marry three more times and father two more children, Diana and Ann, by his third wife, Elsie Foss. His fourth marriage, to Nannie Dale Biddle, in 1933, and his last, to Majorie Young, in 1945, were both childless.

Starling Burgess was widely respected as a yacht designer as well as an aviation pioneer but his timing was always off, as was his judgment in business matters. His tempestuous affairs, marriages, and divorces — unfortunately connected to his social and professional circles — created additional problems, including bankruptcy and several contemplated suicides, and were definite factors in his never achieving financial success or the acclaim he so desired and, given his brilliance in both yachting and aviation, probably deserved. Physically he suffered from a severe, long undiagnosed gastric ulcer, which contributed to decades of near addiction to morphine.

Tasha's father, William Starling Burgess.

A friend of Starling's last wife, Majorie. wrote to her prior to their marriage and, according to Tasha, described him accurately: "With all his brilliance, he is a child, and that is part of his charm. He will not face hard facts, but will hide from them and will love the person who shields him from them." It is ironic and sad that a number of Tasha Tudor's friends and professional colleagues agree that the description is equally appropriate to his daughter as well. Perhaps it is a price that must be paid for genius.

Although Tasha sometimes visited her mother's studio in Greenwich Village or wintered with her in Bermuda, Rosamond wasn't any more involved in her rearing than was her father. Tasha was essentially allowed to do as she pleased. When socializing with her mother's friends in New York, she would invariably be introduced as "Rosamond Tudor's daughter, Tasha." Everyone assumed, therefore, that her name was Tasha Tudor. Tasha liked the sound of it and stopped using Burgess as a last name. Her name wasn't legally changed until decades later, when she needed a passport and wanted it in the name she had become accustomed to using.

Visits to her grandmother's home on Beacon Hill maintained a Boston connection, and she spent several years at boarding school, but the greatest influence on her creative development came from the Mikkelsons. Members of the family wrote and directed plays, casting themselves and a host of friends in a variety of roles. All of the children were encouraged to write, act, and immerse themselves in whatever creative endeavors interested them. For a time, Tasha considered becoming a dancer, and was considered quite promising.

Perhaps as a positive way to deal with parental abandonment, Tasha idealized both her mother and father. She described her father as "a bird of paradise in a family of English sparrows" and delighted in his accomplishments.

One of Tasha's favorite stories about him doubtless fed her love of fantasy and her somewhat unorthodox beliefs about an afterlife. Tasha believes that heaven consists of whatever one wishes it to be. In her case, she fully expects to return to life in the 1830s, where she is convinced she once lived.

Tasha Tudor as a child, painted by her mother,
Rosamond Tudor.

"Papa had a recurring dream all his life of a beautiful, walled medieval city. He would approach it in his dream but he could never enter. The doors and gates were always locked. He would look at all the towers and balustrades and know that it was beautiful within. He longed to enter but never could.

"One morning as he was reading the newspaper, he looked up and said to Majorie, his last wife, 'Majorie, I had my dream again last night and I finally found the key to the city.' With that, he fell over dead. He must have entered that city at that exact moment. What a wonderful way to step forth into something new!"

Tasha credits her mother with inspiring her to become an artist. "My brother Frederic and I used to take our baths together. It was a large tub, and Maman would come up and wash her brushes when we were having our baths. She would always save a nice juicy one for us and she

would paint a face on our bare tummies. When we expanded or deflated them, the expression on the face changed. It was highly entertaining. Then and there, I decided that I would become an artist. As I usually get what I want, I did become an artist. I highly recommend it as a career."

Tasha did decide as a child to become an illustrator, and the influence her mother had on her development as an artist is significant. On visits to Rosamond's studio, Tasha would read to sitters as they posed for portraits. She observed firsthand and up close her mother's academic techniques and style. Rosamond Tudor had both the talent and the connections to become a society portraitist of the first order. What she lacked was the ambition to do so. She was, however, an excellent teacher, even if only by example.

Tasha watched and applied all she observed. She wrote and illustrated several unpublished books during those early teenage years. Although naive when compared with her later work, they helped her develop the skills she would use to such advantage in her future career.

During those same years, Tasha laid the groundwork for the lifestyle she would eventually hone to perfection. She began a nursery school in Bermuda, where she spent several winters with her mother as the guest of two aunts. Already her desire was to have a farm and become self-sufficient. She saved the money she earned from her school with the intention of buying a cow. When her uncle Rico Tudor gave her that first cow, she put the money aside as her stake in the future she imagined so vividly.

An inheritance from her aunt Edith Burgess in her late teens gave Tasha furniture, family heirlooms, and, most important to her, the implements of a well-stocked kitchen. The modest amount of money included in the bequest was of no use to Tasha, as Rosamond promptly borrowed the entire amount and never repaid the loan. "I knew she wouldn't, of course," Tasha admitted wistfully half a century later, "but, quite frankly, I cared more about the kitchen things. Maman wasn't interested in them, so I felt secure and fortunate. I still use them all."

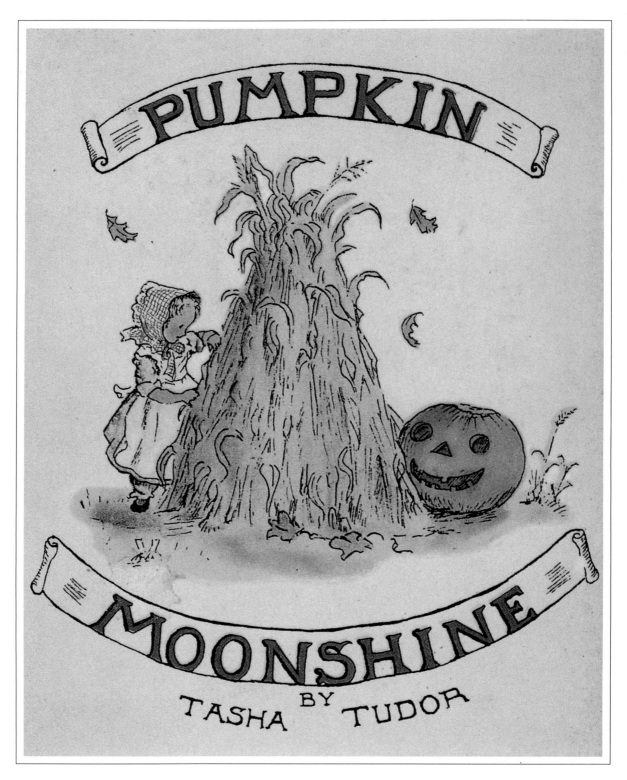

Tasha's "calico" books, *Pumpkin Moonshine, Alexander the Gander, The County Fair, Dorcas Porkus,* and *Linsey Woolsey,* are notable for their nostalgic charm as well as Tasha's perseverance in bringing them to publication.

PERSISTENCE

Tasha Tudor's first book, *Pumpkin Moonshine*, would never have been published had it not been for her extreme persistence. Originally, it was never intended for publication at all. In the tradition of Beatrix Potter's *The Tale of Peter Rabbit*, which first came to life in a letter written to cheer up five-year-old Noel Moore, ill with scarlet fever, *Pumpkin Moonshine* was conceived as a Christmas present for the young niece of Tasha's new husband, Thomas McCready Jr. Sylvie Ann, also five years old, was coming from England for a visit, and Tasha wanted to welcome her with an original gift. One of the most extraordinary careers in children's literature evolved out of that seemingly simple decision to make a child's Christmas present, and Sylvie Ann went on to become the heroine of five well-known "calico" books.

Pleased with the art when she finished *Pumpkin Moonshine*, Tasha borrowed it back from Sylvie Ann, as Potter had done with her letter to Noel more than a quarter century before, and made the rounds of publishing houses. Tasha insists that she personally visited "every publisher in New York." They were unanimous in their rejection. With a persistence that would mark her life and

her career, Tasha remained undaunted. "They couldn't visualize what I wanted it to look like, how perfect it would feel in the hands of a child. So I had to show them."

Tasha sewed the pages together, bound the covers in blue polka-dotted calico, and vowed to revisit "every publisher" again. She didn't have to. In one of publishing's fortuitous moments of perfect timing, Tasha chose Oxford University Press as her first stop on the second round. Eunice Blake was Oxford's newest editor, and she had yet to acquire a book for publication. She met with Tasha, and they liked each other immediately. More important, she liked *Pumpkin Moonshine.* She accepted it on the spot, and an extremely successful relationship began. Oxford would publish Tasha's books exclusively for sixteen years, twenty-one books in all. Both of Tasha's Caldecott Honor books, *Mother Goose* and *1 Is One,* would be published by Oxford, and some of her most memorable and most reprinted books would be written and illustrated during her time there. Of the twenty-three books she would both write and illustrate, fourteen were done during this period. It was a productive time for Tasha, and she built a solid foundation as both an author and an illustrator.

With the exception of *Fairy Tales from Hans Christian Andersen,* the illustrations from this period lay the groundwork for most of the art that would be considered characteristic of Tudor's mature style. The art in *Fairy Tales* seems to reflect the influence of British illustrators Tasha liked in her childhood, notably Edmund Dulac, Arthur Rackham, and W. Heath Robinson. Each time Tasha returned to classic fairly tales, this influence seemed to reemerge. It is certainly at odds with her own, original style, which might be described as quintessential New England. Tasha isn't fond of these illustrations, perhaps because they are vaguely derivative. When the color piece from "The Real Princess" was chosen as one of three of Tasha's works to be included in a major exhibition of children's book illustrations, Tasha ordered me to "put a stop to that one." I offered the curators anything we had in place of it, but they were curatorially steadfast in their decision. Along with *There Was the Big Tent* from *Corgiville Fair* and a panel from *A Time to Keep*'s "October," the Princess was exhibited in 1996's *Myth, Magic, and Mystery, One Hundred Years of American*

Children's Book Illustration, which began its tour at the Chrysler Museum in Norfolk, Virginia, and went on to the Memphis Brooks Museum and the Delaware Art Museum. We were in Williamsburg that July, preparing for the exhibition there, and Tasha and I visited the Chrysler Museum. She enjoyed the exhibit and was justly proud of being included. When we passed the Princess, however, Tasha turned away. "I didn't like her then and I don't like her now."

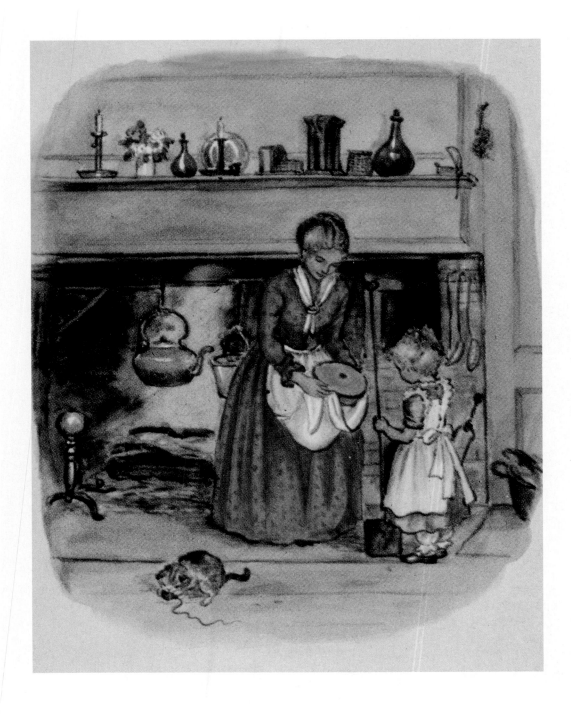

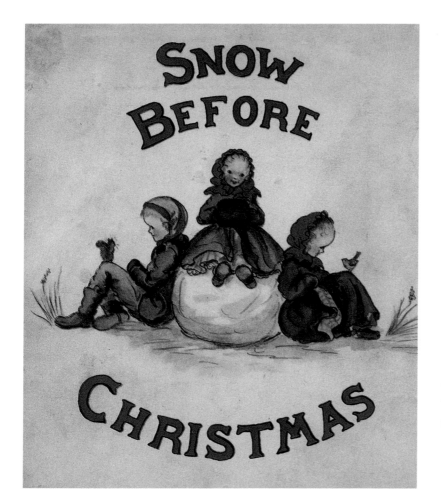

Snow Before Christmas, 1941,
was Tasha's first depiction of
an old-fashioned Christmas.

When I probed, it turned out that her dislike of the piece was partially due to the memory

of how difficult her life was at that time. Thomas McCready was an unwilling participant in

the lifestyle Tasha was determined to have, and he expected her to both maintain a household of

four children and turn out books quickly enough to support them. This period was hard for Tasha,

and she remembers the children as being "absolutely awful" while she completed the fairy tale

illustrations.

Her children provided Tasha with a never-ending source of material and models. "Bethany was

perfectly beautiful to draw. Efner was wonderful. . . . When I illustrated fairy tales, Efner was always

the princess," Tasha remembers fondly. "Seth was very good about posing. He was a very quiet

baby, sitting still for hours. Tom was fine as a model, but he could be a holy terror. I was constantly running to get him out of trouble."

Mother Goose, produced in 1944, is one of Tasha's best books, full of intricacy and detail. The delightful interplay between children and animals and the joyful innocence of childhood that Tasha would portray so vividly in her later work have reached a peak of accomplishment here. The illustrations in *Mother Goose* are classic, and it remains one of the best editions ever done. It won Tasha her first Caldecott Honor. In addition to wonderful watercolors, the pencil drawings are remarkable.

"Goosey, goosey, gander, whither dost thou wander?," p. 75, *Mother Goose,* 1944.

"Sing, sing! What shall I sing? The cat's run away with the pudding bag string," p. 68,
Mother Goose, 1944.

Tasha's pencil sketches often show a delicacy of detail equal to, and sometimes surpassing, her watercolors. She has kept sketchbooks since she was ten. "Sketching is a pleasurable thing to do. It's all about how you feel about what you see. It's like playing God. You can make the world look as you want it to."

I was amused one day when going through her early sketchbooks to have Tasha declare solemnly, "There's nothing there that I didn't draw from life," shortly after I had seen a tiny sketch of a dinosaur. I flipped back to it, wordlessly, and held it up for her to see. She barely glanced at it as she left the room. Pausing at the doorway, she looked back. "Many lives," she said, with no hint of a smile.

"Toward evening the others came back," p. 142, *Fairy Tales from Hans Christian Andersen*, 1945.

Lavish borders full of surprises and activity have become one of the elements most associated with Tasha's illustrations. Other illustrators have successfully used this idea, but Tasha has made it uniquely her own and, in a rare moment of self-examination of her art, once confided to me, "If I'm remembered for anything, it will probably be my borders."

Although she had utilized decorative borders as book-plates for the calico books and as cover art or endpapers for *A Tale for Easter* and *Mother Goose,* her first serious and consistent use of borders appears in her 1947 edition of *A Child's Garden of Verses.* Simple and floral, they are a forerunner of Tasha's imaginative and exuberant borders showing worlds within worlds. They expertly define and frame the limits within which she works and give her a sense of nesting in her work, a habit she reinforces in life.

Bed in Summer, p. 15,
A Child's Garden of Verses, 1947.

While any list of Tasha's "best" books is subject to personal taste and changing criteria, it would be difficult to exclude this edition of verses. The Tudor children must have been on their finest behavior, because the children Tasha illustrated here approach perfection in their gentle, calm contemplativeness. The watercolors have acquired depth and dimension and the pencil drawings have possibly exceeded the level of accomplishment she displayed in *Mother Goose.*

A Child's Garden of Verses,
1947, p. 117.

Winter-Time, p. 65,
A Child's Garden of Verses, 1947.

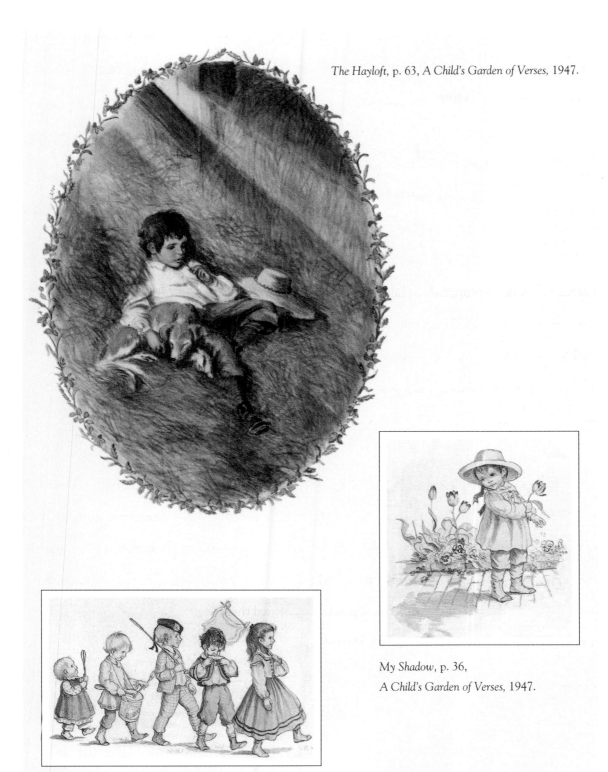

The Hayloft, p. 63, *A Child's Garden of Verses*, 1947.

My Shadow, p. 36,
A Child's Garden of Verses, 1947.

Marching Song, p. 39, *A Child's Garden of Verses*, 1947.

Sethany Ann and Nicey Melinda, cover art from *The Dolls' Christmas,* 1950.

Two of Tasha's most endearing books came in the early 1950s. *The Doll's Christmas* celebrated what would come to be one of the Tudor family's most cherished and well-known Christmas traditions, that of having the children's dolls and stuffed animals celebrate Christmas doll-style while Tasha finished preparing the family's own life-size celebration. Tasha's dollhouse was first mentioned in the distinctively cheerful and uniquely Tudor-like story of *Thistly B,* but it came into its own in *The Doll's Christmas.*

Sparrow Post, Tasha's means of communication with the children, their dolls, and toys, distant doll relatives, and friends, was first introduced here, as was the family's annual marionette show. Each of Tasha's children actually had a mailbox, and letters from dolls, toys, and imaginary friends or mail-order companies appeared regularly, the service being credited to Sparrow Post. Sometimes the dolls began stories that Tasha later developed into books.

The Doll's Christmas is a recognizable landmark in the development of Tasha's career both as an illustrator and as a budding lifestyle icon, even though the latter category had yet to be established.

Although all the books she had written and illustrated thus far had been autobiographical to some degree, Tasha was now depicting children old enough to begin contributing their own personalities to the rich fantasy life Tasha created for them. The children didn't always appreciate the eccentricities that made their mother different from the parents of their friends. "When they were little and I would infrequently go to town, they would always walk a good ten or twenty feet behind me because I dressed a little differently from the others. They didn't want people to think we were connected in any way." Holiday celebrations, however, were the times they most enjoyed and most joined in with the fantasies.

When her children were young, Tasha often kept sketchbooks in various places around the house so they would be easily available if a pose caught her fancy. "Art was a natural part of my children's lives. They were all used to being models for my illustrations. To get them to pose, I had to sometimes bribe the boys with chocolate. The girls posed out of sheer vanity."

"Two days before the party Laura and Efner dressed Nicey and Sethany in their warmest clothes and took them to the woods to get the dolls' Christmas tree." *The Dolls' Christmas,* 1950.

The Doll's Christmas helped Tasha to realize she could live the life she chose and created, and use it as inspiration for her illustrations. It was at this point that her life and art would start to intermingle, with reality and fantasy becoming a curious blend. Her sharing of her family's Christmas celebration would begin to influence families all over America. Countless little girls began having "a doll's Christmas," the gentle beginning of an interest in Tudor's lifestyle that would reach a crescendo decades later.

Amanda and the Bear, based on a true story from the family of one of Bethany's friends, and *Edgar Allan Crow,* inspired by the Tudor family's pet crow, followed the success of *The Doll's Christmas. A Is for Annabelle* came next and remains as charming today as it did when it first appeared. Tasha used a family doll named Melissa, which had belonged to her aunt Edith Burgess, as the inspiration for Annabelle and her extensive wardrobe. The simple rhymes are suitable for introducing young children to the alphabet, and Tasha's watercolors and drawings show an obvious affection for her heirlooms. Once again, she uses floral borders to good effect.

The patterns of Tasha's life and art were set. Though she would alter them slightly to accommodate changing circumstances, there would be limits and she would control them as much as she could.

After *A Is for Annabelle,* Tasha would have only three more books published by Oxford while creating a new series with another publisher, Ariel. *First Graces* would be a companion piece to *First Prayers,* and while popular, neither showed Tasha at her best.

1 Is One, written and illustrated in 1956, was a companion volume to *A Is for Annabelle,* this time teaching children to count. It was as well executed as the alphabet version and won Tasha her second Caldecott Honor.

Around the Year, in 1957, was Tasha's last book for Oxford, which had sold its children's division to its departing president, Henry Z. Walck. A third companion volume to *A Is for Annabelle* and *1 is One, Around the Year* taught children the months of the year and the joys associated with

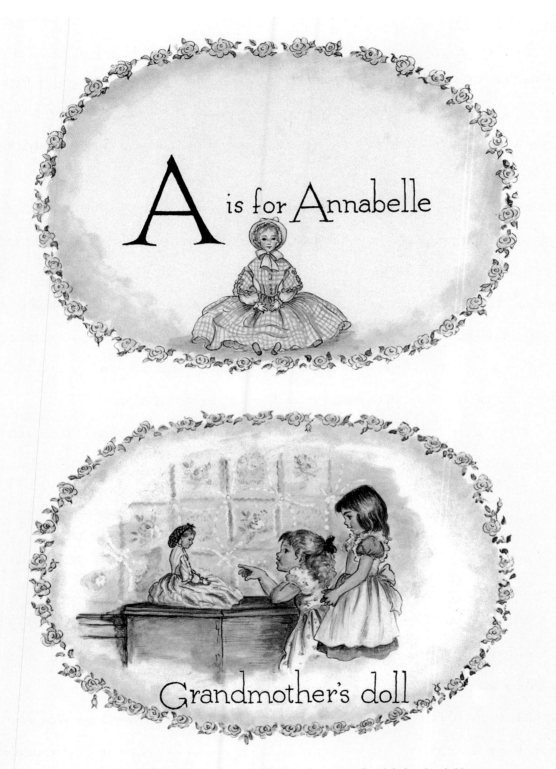

A Is for Annabelle, 1954, was a memorable introduction to the alphabet for children, who were fascinated by Annabelle's well-appointed wardrobe.

each season. It is one of her finest works, introducing readers to the simple rural New England lifestyle of Tasha's family. The old-fashioned joys of farm life were beautifully presented in watercolors and pencil drawings and took on an ideal quality Tasha would work hard to preserve in her own life. It was the life both she and her fans wanted.

1 Is One, 1956, was the second in a series designed to teach beginning readers the alphabet, numbers, and the months. Tasha won her second Caldecott Honor for *1 Is One.*

1 is one duckling

swimming in a dish

coasting,

the hope of spring,

Around the Year, 1957, was the third, and last, in the series teaching young children the alphabet, numbers, and the months of the year. The softly detailed illustrations are among Tasha's best work.

brings the day,

Around the Year, 1957.

The thirtieth-anniversary edition of *Becky's Christmas*, published by the Jenny Wren Press in 1991, featured a new cover highlighting the New Hampshire farmhouse in which Becky (actually Tasha's daughter Bethany) grew up.

THE ARTIST AS WIFE

When Tasha and Tom McCready married in 1938, they lived in Tasha's mother's house in Redding, Connecticut. Two of their children, Seth and Bethany, were born there. Tasha's dream was to live the rural life she had embraced since childhood and to be independent. When her advances and royalties, most substantially those from *Mother Goose,* made it possible for her to establish a home for her family, she did so with enthusiasm, in 1945.

The McCreadys found a seventeen-room, eighteenth-century house in New Hampshire situated on 450 acres of woods and fields. It was a compromise meant to accommodate Tasha's longtime desire to live in Vermont. McCready was less comfortable in largely rural areas. It would be their home for a number of years, hers alone for a bit longer. The house and land would provide her with the environment she needed to create the life she had imagined and the art that such a life inspired. Two more children, Efner and Tom, would arrive.

For almost a decade Tasha devoted herself to restoring the dilapidated old house, producing some of her best work and raising four energetic children along with an ever increasing menagerie. She apparently received little help from McCready. They seem to have had no real interests in common, and his tolerance of her chosen lifestyle appeared to exist in direct proportion to the amount of income it produced.

It was not a love match. Tasha once told me she married Tom McCready because "I thought he was the only man who would ever ask me." Since childhood, Tasha had been self-conscious about her looks. As a young child, she had come upon a mirror and looked into it expecting to see "a fairy princess. I felt like one, I imagined myself one, and I expected to see one reflected in that glass. I had never really been conscious of looking into a mirror before. I loved fairy tales, so I thought, 'I'm going to look in the mirror and see a beautiful fairy princess.' I had quite a shock, really, when I looked in that mirror. I've never forgotten that feeling. It wasn't a fairy princess at all, but a very scraggly little girl. It taught me a good lesson, however, not to think you're a fairy princess." Having settled for Tom McCready because she felt too plain to suppose a better offer might come along, Tasha was dismayed when she finally realized that McCready fully expected her to support them. Although Tasha tried valiantly, her income never seemed sufficient. The most-repeated statement Tasha remembers from that period was McCready's urging, "Mommy, you've got to find a way to earn us more money."

Tasha found a way. She hoped she could induce her husband to desire to be productive. With a gentle but determined persistence, she encouraged him to write stories, which she would illustrate, using her prominence to ensure publication of his work. The dust jacket of their first effort, *Biggity Bantam*, refers to Tasha as "almost too well-known in the book world to discuss here."

The collaboration, which produced five "McCready" books, was unimpressive. Tasha herself creatively interpreted the daily goings-on of her family and told those stories to McCready, who then wrote the books. The inspiration for *Biggity Bantam, Pekin White, Mr. Stubbs, Increase Rabbit,* and *Adventures of a Beagle* is certainly pure Tudor imagination, but the stories themselves are wordy

and quite forgettable. The art is competent, but not inspired. Only *Increase Rabbit* stands out as memorable.

When Tasha would return to her own work, the change was obvious. *And It Was So: Words from the Scriptures* is exquisitely drawn and painted. Although religious books are among her least favorite productions, it ranks among the best, if not *the* best, of that genre.

The time when Tasha could be as unduly influenced by someone as she was by Tom McCready was rapidly coming to a close. After the last McCready book, Tasha illustrated *The Lord Will Love Thee.* Under protest, she agreed to the publisher's insistence that she dress her characters in biblical clothing. In fairness, the book *is* an account of biblical times. Despite the desired clothing, the book sold poorly and Tasha was convinced that it would have been more successful had she been allowed to clothe her biblical characters in modern dress.

Tasha began the 1960s by writing and illustrating *Becky's Birthday* and *Becky's Christmas,* with the title character based on her daughter Bethany. They were pure Tasha Tudor. She was beginning to come completely into her own, projecting her family as she wished it to be and removing any

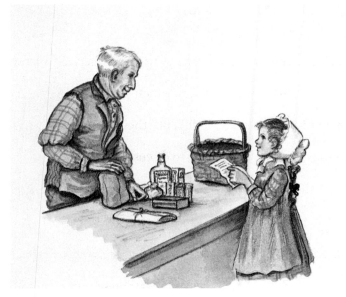

"Becky took out the list and read it off while Mr. Caleb fetched the things, joking and laughing all the while," p. 15, *Becky's Birthday,* 1960.

facet threatening that vision. The Warner family of the McCready books, with the often stilted presence of Mr. Warner, was gone. The emphasis on the family's pets rather than on the family itself was gone as well. Tasha had avoided dealing with the family long enough. She was now ready to re-create her family in the image she wished. The Warners were replaced by a new family with more individually developed personalities, devoted to one another and considerate of each person's place. The father figure was idealized, and Tasha drew on a number of early memories of her own father to round out his character. Necessary because of the work he performed, he was primarily a background figure in a new feminine hierarchy. Tasha was now dictating the terms of the family order. The story lines are more detailed and complex than in her previous books, and the illustrations are warm and inviting.

"Mother was waiting for her on the porch, and Becky handed her the bouquet," p. 30, *Becky's Birthday,* 1960.

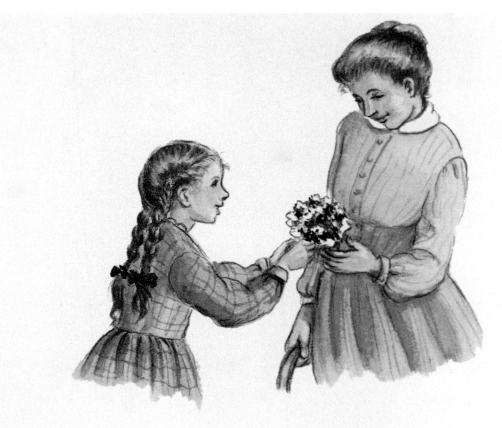

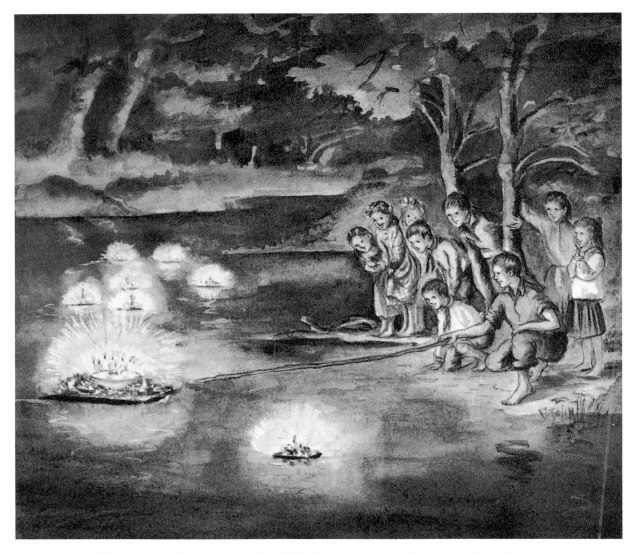

"Floating down the river came a fleet of shingle boats, each with flowers and a lighted candle on it. These were followed by a larger raft of flowers, in the middle of which was Becky's lighted birthday cake!" p. 38, *Becky's Birthday*, 1960.

In *Becky's Birthday* she introduces readers to a surprise that she had once actually prepared for Bethany and that was to become probably the single most memorable scene in Tasha's art. Bethany's birthday is in August, and it was Tasha's custom to have a party for her down at the Black Water River, near their house. One year, at dusk, Tasha floated Bethany's lighted birthday cake down the river on a flower-bedecked raft, to the delight of everyone. Smaller rafts with candles and

flowers served as escorts. It caught the imagination of readers everywhere and became a symbol of the magical approach Tasha brought to her own life.

Becky's Christmas, published in 1961, reinforces the loving family theme and emphasizes and expands on all of Tasha's Christmas traditions, including Advent calendars and wreaths, the crèche in the brick oven, and gingerbread tree ornaments. The old-fashioned warmth of this book is palpable.

She would finish the year with *The Tasha Tudor Book of Fairy Tales.* As always when illustrating fairy tales, Tasha's style reverts to an earlier, more derivative one. There is, however, a decidedly Tudor-like illustration of Little Red Riding Hood talking to the wolf. Most memorable is the continuing evolution of Tasha's borders. They have become more decorative and display her evolving distinctive style.

Ending a long chapter of her life in 1961, Tasha divorced Tom McCready. "It was the best decision of my life!" she exclaimed years later. The children changed their name to Tudor, recalling Tasha's assumption of her mother's

Little Red Riding Hood, p. 81,
The Tasha Tudor Book of Fairy Tales, 1961.

name and rejection of her father's, nearly half a century earlier. McCready would die of pneumonia three years later, in London. Because he was a Christian Scientist, he refused medical treatment, which probably could have saved his life. Ironically, his niece Sylvie Ann, who had inspired the calico books and Tasha's resulting career, also died refusing help, for the same reason. Tasha's only comment about McCready's death was "It was a blessing. He couldn't face old age." I couldn't help but note that it was the same thing she had once said at a lecture about Alexander the Gander's

death. She remembered that "he jumped into a bucket and drowned himself. He really did. It was a blessing. He couldn't face old age."

Tasha would marry once again. It would be brief and somewhat disastrous. "I was lonely," she explained. The only public reference to that ill-fated union can be found on the dedication page of the first edition of *The Twenty-Third Psalm* (1965), a miniature leatherbound volume published by Tasha's friend Archie St. Onge. The page reads, "To My Husband, Allan John Woods." Although official St. Onge records show a first printing nearly three times that of the second, which omitted the dedication, the second printing is far more available today. The great majority of the first edition seem to have disappeared. The edition without the dedication

Endpapers, *The Tasha Tudor Book of Fairy Tales,* 1961.

portrayed the world more as it should be, not as it was. One of Tasha's favorite quotes is from Henry David Thoreau's *Walden:* "If one advances confidently in the direction of his dreams, and endeavors to live the life which he has imagined, he will meet with success unexpected in common hours." Tasha was moving rapidly in that direction.

The cover art for Tasha's version of *The Secret Garden*, 1962, is one of her most recognized paintings. The book has been in print continuously since it was first published and has sold more than 3 million copies.

FRESH START

With her divorce from McCready behind her, Tasha began the most prolific decade of her career. Over the next ten years, from 1962 to 1971, she would illustrate twenty books, several of them pivotal to her ever expanding reputation.

A 1962 miniature version of *The Night Before Christmas* is notable because Tasha would illustrate this classic two more times, in 1975 and again in 1999, altering and honing her vision of what Saint Nick should look like.

In 1962 Tasha also illustrated a landmark edition of Frances Hodgson Burnett's *The Secret Garden*. The illustrations are a beautifully executed interpretation of the characters but are done in a clearly recognizable Tasha Tudor style. This edition has been continuously in print since it was first published. It placed Tasha among the best-selling illustrators of all time, with the hardcover and paperback editions combined selling well over 3 million copies. Another Burnett classic, *The Little Princess*, followed in 1963.

The Secret Garden should have given Tasha permanent financial security, but she had negotiated her own contract, as usual, and had agreed to accept a flat fee as full payment, waiving the rights to any future royalties. Originally, she was paid $500 for illustrating the book, but as it became increasingly successful, her editor felt so sorry for Tasha that she sent her an additional $500, bringing the total payment to $1,000 for illustrating one of the most popular children's books ever published. In 1989, *Publishers Weekly* issued a list of all-time bestselling children's books and placed the cloth edition of Tasha's version of *The Secret Garden* at number twenty-six and the paperback edition at number fifty-six.

Tasha did everything her own way, frequently to her financial detriment. She was often offered, and accepted, contracts an agent would have advised her to decline. In the case of *The Secret Garden*, there were two motivating factors for Tasha. She wanted to illustrate Burnett's classic for increased credibility, and she also needed the money immediately. Financial pressures often induced Tasha to make unwise choices. Her divorce and the education of her children were a tremendous drain on her resources. All of Tasha's children were given excellent educations at some of New England's best, and most expensive, schools. There was always a pressing financial need.

Tasha rarely used literary agents until quite late in her career. One had only recently been retained when we formed Corgi Cottage Industries. She had not trusted their advice, nor had she wanted to pay their commissions.

Wings from the Wind (1964), contains a number of amusing sketches, including a cat reading in a rocking chair and a cow sipping her drink through a straw while reclining in a hammock. The sense of whimsy hinted at here would become fully developed by the time Tasha created *Corgiville Fair* seven years later, an entire world where normally incompatible animals live fairly harmoniously. To add a bit of spice to the community, Tasha included her version of Swedish trolls, whom she calls bogarts. They are somewhat wild and mischievous and possess many human foibles, which Tasha uses to narrative and pictorial advantage. One of the earliest appearances of a bogart in Tasha's work is seen in a border introducing the "Nonsense" section of *Wings from the Wind*.

"'My last voyage,' began the Sea Rat," p. 177, *The Wind in the Willows*, 1966.

Two other milestone books appeared near the middle of Tasha's prolific decade, both in 1966. Tasha's version of *The Wind in the Willows* is a delicate and definitive rendering of the famous classic by Kenneth Grahame. The animals depicted in watercolors have a realistic feel and seem perfectly at home in clothes, houses, and motorcars. The extensive pencil drawings are among Tasha's best.

Table of Contents, *The Wind in the Willows,* 1966.

"A brown little face, with whiskers. A grave round face, with the same twinkle in its eye that had first attracted his notice. Small neat ears and thick silky hair. It was the Water Rat," p. 21, *The Wind in the Willows,* 1966.

"'Then look here!' said the Rat. 'You get off at once, you and your lanterns and you get me —,'" p. 107, *The Wind in the Willows,* 1966.

In the tradition of Beatrix Potter, even when Tasha draws anthropomorphically, real animals are her models. The subtly rich drawings in *Wind in the Willows* were inspired by real-life counterparts. All of her pets have served as models, as did Potter's. In addition to her corgis, cats, goats, and birds, Tasha frequently keeps deer mice or other animals she has rescued. Her easy relationship with nature enables her to move effortlessly among creatures of the woods, which seem to observe her with the same intensity she focuses on them.

When live models aren't available, Tasha uses carefully preserved dead animals, kept in a basement freezer. Her "mouse morgue" frequently contains as many as a dozen occupants. She sometimes prefers these models to live ones because, when partially thawed, she can pose them in

Getting Ready, Christmas card, 1968.

various positions. In addition to mice on ice, she has had a variety of frozen birds, including an owl that posed for many years. All of her animals, alive or dead, appear over and over in her work, and she has many sketchbooks devoted entirely to one species or breed.

The year 1966 also saw the publication of one of Tasha's best-known works, *Take Joy! The Tasha Tudor Christmas Book*. It is a collection of songs, poems, and stories about Christmas, many of them personal to the Tudor family. Recipes and advice on making decorations and staging celebrations made *Take Joy!* a forerunner of the how-to and lifestyle books that would enjoy enormous popularity decades later. It is an extraordinary compendium of all the Christmas legends and customs that had influenced Tasha and the unique expressions of them she had developed on her own.

A *Bountiful Border*, Christmas card, 1973.

The title came from another of Tasha's favorite quotes, this one from a letter written by Fra

Giovanni in 1513. "The gloom of the world is but a shadow; behind it, yet within our reach, is joy.

Take joy." Those two words *take joy!* would become a signature phrase, closely associated with

Tasha and symbolic of the lifestyle that she projected and that her fans felt they could emulate,

with her as their guide.

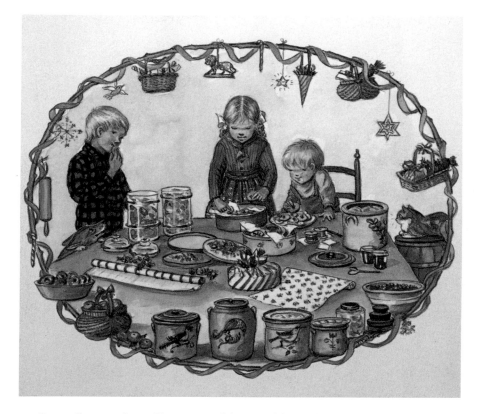

Originally painted as a Christmas card, later used for *Cookies*, p. 104–05, *The Tasha Tudor Cookbook*, 1993.

The section "Tasha Tudor's Christmas" would firmly entrench Tasha as the doyenne of Christmas, and as her books came to be published in other countries, she idealized what an American Christmas was all about. *Take Joy!* epitomizes Tasha's ability to live a life and illustrate that life to perfection, thus covering over the real-life imperfections with exquisitely applied paint and, thereby, making life imitate art. Christmas is the ideal subject for Tasha's graceful borders, and several in *Take Joy!,* especially the dedication page, are masterfully done.

One of the artistic strengths of *Take Joy!* is the use of Tasha's Christmas cards. For more than twenty-five years Tasha had created a minimum of twelve to fifteen cards a year, mostly for the Irene Dash Company. Through an extensive distribution, Tasha's cards carried her distinctive New England version of Christmas all over the world.

Aglow for Christmas, Christmas card, 1968.

Command Performance, Christmas card, 1969.

Country Chore, Christmas card, 1961.

The painting of Christmas cards was interspersed with work on her books, and the cards were frequently incorporated into the books, but their use in *Take Joy!* was the first time a number of them had appeared together. When painting the cards, Tasha drew heavily on her children and their farm life for inspiration. The cards record their growth, their development of classic Tudor customs, and their wonderment as each succeeding Christmas unfolded.

At the twilight of her long and successful life and career, Tasha often credits her garden as the greatest source of inspiration. But Christmas must share that place of honor, as her Christmas cards reflect.

Hundreds of designs beautifully depict all the bygone joys we associate with Christmases of a century ago. They come alive on Tasha's cards because she wasn't creating them from her imagination; she was simply recording them as she and her children lived them.

The Tudor children have lived a remarkable life, idealized and immortalized in their mother's art, but it was often difficult from a practical standpoint. Tasha's daughter Bethany has said, apologetically, "My mother raised me in a fantasy world. She did not prepare me for the real world." Even so, one cannot help but envy the Tudor children their Christmases. Tasha's Christmas cards illustrate the history and development of their childhood observances. They depict many of the ordinary joys of Christmas on a nineteenth-century farm, including sledding, making wreaths, decorating the tree, and baking cookies for gifts. In addition, Tasha's unique touches are apparent in the hanging of the Advent wreath, the making of large gingerbread ornaments, the staging of elaborate marionette shows, and the holiday celebrations of the family's dolls and toys. The livestock are also included in the season's observances and are always provided with special treats. The doughnut tree for the birds and squirrels is a particularly endearing touch.

Tasha's Christmas cards with a religious theme are perplexing when one considers that, today, Tasha has a highly iconoclastic approach to religion. She used to delight in torturing me at public appearances whenever someone questioned her about religion. Her eyes would seek me out and taunt me as she slowly formulated an answer, usually, fortunately, oblique. She knew the things I hoped she wouldn't say and she complied, as conscious of her public image as I was, but only after assuring me with her eyes that she could, if she wished, create controversy. She disliked, to varying degrees, most of her religious illustrations and thought people wasted far too much of their lives in spiritual contemplation.

Christmas card.

Feast in the Farmyard, Christmas card, 1956; later published as the print *Suppertime,* 1997.

"Anything forbidden to a Christian is just the thing to have!" she says, and prefers to spell God N-A-T-U-R-E. She and I share a somewhat pantheistic approach to religion, but an examination of her many Christmas cards celebrating the religious aspect of the holiday indicates that she had a more conventional approach to the subject as she raised her family. Her many depictions of the Nativity show an absolute reverence for the baby in the manger. Her paintings of two memorable crèche scenes, one in the brick oven next to her fireplace and the other under an outcropping ledge of stone, reachable only after a lengthy journey through a dark, candlelit forest, have left a permanent imprint on fans everywhere. The consistency of her reverence in cards depicting the

Children's Adoration, Christmas card, 1973.

Christ child perhaps belies later-life attempts to disassociate herself from former beliefs. Her love of Christmas itself seems to have encompassed its religious foundation.

Tasha's Madonnas are a delightful blend of typically Tudor-like New England farm girls presented in often classical composition. That long-ago stable was a real one to Tasha, filled with animals needing to be fed. Frequently, baskets of apples for the animals are present. Tasha considers Mary a simple woman, her clothes reflecting the busy life she led. Always evident, either through lighting or facial expression, is the tenderness and love between mother and child.

Tasha herself often appears in her work, showing up as a Madonna or young mother. Motherhood left an indelible impression on Tasha and has influenced most of her published works. She is aware of the tendency to portray herself from that period. "I sometimes draw myself. I don't do it consciously, but I do it all the time. That's just something an artist does."

In 1968 Tasha illustrated another classic, Louisa May Alcott's *Little Women*. Her deep affinity for earlier time periods is apparent in both the pencil and the watercolor illustrations.

To cap off the astonishing decade when she produced illustrations for two or three books a year, Tasha created a tour de force with the 1971 publication of *Corgiville Fair*, the most original of her books and the one she will probably be most remembered for. It is her favorite.

"The Browns live on a farm outside the village. There are Mr. and Mrs. Brown and three puppies: Caleb, Cora, and Katey," *Corgiville Fair*, 1971.

"Caleb felt a keen excitement. He was confident about Josephine and her potential for speed. He spent more time than ever over her appearance and her diet. He watched her weight like a teenager," *Corgiville Fair*, 1971.

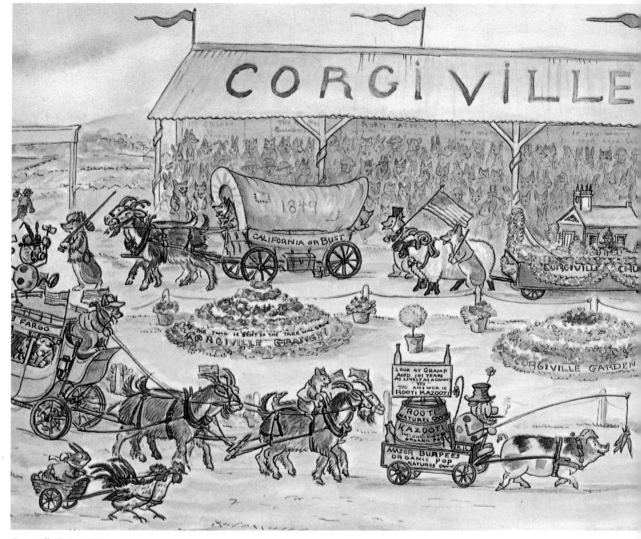

Corgiville Fair, 1971.

Corgiville is a unique village populated by a variety of animals, including rabbits, cats, bogarts, and its namesake corgis. Tasha used the real town of Harrisville, New Hampshire, as the model for the architecture of Corgiville. The inhabitants live a seemingly simple life, obviously based on Tasha's own, but one, beneath the surface, as richly complex as hers as well. Life in Corgiville is exactly as Tasha wishes it to be — reminiscent of an earlier, idealized America — not free of all problems and character flaws, but slow-paced and charmingly innocent. All the various species live in relative harmony with individual pursuits, all contributing to the complete world Corgiville represents.

Tasha took the best of life as she had created it and wished it to be, and transferred it to this mystical village "west of New Hampshire and east of Vermont." The joy she took in its creation is evident. The illustrations are fresh and completely beguiling. Though they can't escape being compared, in concept, with Beatrix Potter's, Tasha's intricate development of the world she has created is definitely her own.

Details of dress and furnishings are rich. The dinner held by the ladies of the Corgiville Congregational Church is mouthwatering, and from the expressions on their faces, the conversation would be equally delicious.

"You know about cats and rabbits, but you may not be familiar with corgis and bogarts. Corgis are small dogs the color of foxes. They have short legs and no tails. They are enchanted. You need only to see them by moonlight to realize this. Bogarts are trolls. I believe they came from Sweden, but I'm not sure. The bogarts that live in Corgiville are the olive green kind with spots. Their hair is moss, their ears are leather, and their arms come off for convenience when going down holes. They have long tails and smoke cigars and are apt to be wild," *Corgiville Fair*, 1971.

Dedication page, *Corgiville Fair*, 1971. Tasha has had many *corgyn* — Welsh for corgis, according to Tasha — over the years, and *Corgiville Fair* is dedicated to the most memorable of them.

All the details of a busy life in a small community are present. Tasha's gentle humor comes through in nuances one could miss on first glance. On the wall of the stable hangs a hardware store calendar featuring a female corgi reclining, pin-up-style, on a lounge.

At lectures, Tasha would often say, offhandedly, "I prefer corgi pups to babies any day!" and draw mildly shocked laughter from her fans. They assumed she was joking. She was not. Raising four children under spartan conditions apparently satiated her desire for contact with children in general, who often don't respond as one might wish. Corgis are much more predictable.

Tasha is generally credited with popularizing the breed in America, and her description of them in *Corgiville Fair* has been often quoted: "Corgis are small dogs the color of foxes. They have short legs and no tails. They are enchanted. You need only to see them by moonlight to realize this."

Tasha's enchantment with corgis began in 1958, when upon her return from an extended stay in England, a young corgi was shipped home for her son Tom while he was still in school in England. By the time Tom arrived back in New Hampshire, Tasha and the corgi had bonded; he became the first in a long line of companions Tasha has enjoyed and painted ever since. The corgis or *corgyn*, in Welsh, according to Tasha, appear repeatedly in her work and are probably the most recognized and identifiable element of her art.

Corgiville Fair was a creative triumph for Tasha, and its commercial success enabled her to embark on yet another stage of her life. She sold her home in New Hampshire and bought several hundred acres of isolated woodland in Vermont that she called "my blank canvas." The house she would build there would be named Corgi Cottage, and the world surrounding it would become as unique as Corgiville itself.

October, A Time to Keep, 1977.

A BLANK CANVAS

By the end of her most productive and enjoyable decade, one in which she demonstrated her ability to create and lead an original life as a strong, independent woman, Tasha had achieved both commercial and critical success. In early 1971 Tasha had been awarded the prestigious Regina Medal by the Catholic Library Association. The medal is presented annually for a body of work rather than a specific book, to "an individual whose lifetime dedication to children's literature has made him an exemplar of the words of Walter de la Mare, 'only the rarest kind of best in anything can be good enough for the young.'" Tasha had finally met with Mr. Thoreau's "success unexpected in common hours." She was poised for a new challenge and fresh inspiration for her art and life.

In November of 1971 Tasha was busy helping her son Seth build the new house. The design was based on a friend's house Tasha had long admired. The construction of the house, built entirely by hand without the use of power tools, and the evolving design and layout of the gardens would take years, and Tasha's next book didn't appear until 1975. When it did, all of her vision and labor

was apparent. In Tasha's second version of *The Night Before Christmas*, her new home appeared for the first time.

The book is certainly one of the definitive versions of the poem and as Tudor-like as anything she has done. Mice holding lighted matches aloft guide Saint Nicholas to the rooftop. He has become decidedly more elfin than in her first version, and his interaction with the cat, the corgi, and the toys-come-to-life, which he delivers, is whimsical, magical, and exactly in the spirit of the Christmases readers wished they had had. Tasha's joy in his coming is apparent and infectious.

Tasha's delight in her new surroundings, and the freedom she felt in her life now that all her children were grown, is evident in the new period of writing and illustrating she embarked upon. For the next nine years she produced from one to four well-crafted books a year, a few of which are superb examples of quintessential Tasha Tudor.

The Christmas Cat, published the year after *The Night Before Christmas*, was the first of three collaborations with her daughter Efner. Tasha's serene illustrations are well suited to Efner's story of a cat seeking a home on Christmas Eve. Both convey the possibility of magic in everyday life. The two other books written by Efner Tudor Holmes and illustrated by Tasha are *Amy's Goose* (1977), and *Carrie's Gift* (1978).

A Time To Keep (1977), presents all of the holidays as observed by the Tudors. Son Tom is the adult pictured in the illustrations, and Tasha has become Granny. Grandchildren have joined the children of memory and sketchbooks, and they all cavort in their long-familiar activities amid the familiar surroundings. The art is alive with a subtle vibrancy, and the past is revisited and revised to perfection. Once again, Bethany's cake floats down the Black Water River, more masterfully rendered this time. The book is one of Tasha's most nostalgic re-creations of the life, both real and imagined, of her family.

The high regard Tasha herself has for *A Time to Keep* can be judged by the fact that she kept the entire set of illustrations intact, refusing to sell any, even though by now her originals had begun to

We always had the most wonderful Easter egg tree with goose, duck, chicken, bantam, and pigeon eggs. On the very top were canary eggs.

April, A Time to Keep, 1977.

command high prices. Only once before had she kept a complete set of illustrations, carefully preserving all the paintings from *Corgiville Fair*.

Springs of Joy (1979), lacks the continuity of *A Time To Keep*, being a commonplace book of Tasha's favorite quotes, but it contains some excellent individual examples of her work, including two ethereal shadow children taking a moonlit walk through her garden, and the piece most associated with Tasha, *Laura in the Snow*.

Rosemary for Remembrance, published in 1981, is a diarylike keepsake book, as memorable for its gentle form as for the illustrations themselves. It contains a hauntingly beautiful portrait of a

"At Christmas I no more desire a rose than wish a snow in May's newfangled mirth," *The Springs of Joy,* 1979. This illustration, while painted for a quote from Shakespeare's *Love's Labour's Lost,* is more popularly known as *Laura in the Snow* and is one of Tasha's best-known pieces.

woman dramatically lit by the window she faces. That same year saw the publication of two other books, including a new version of *A Child's Garden of Verses,* one of Tasha's best and most lavishly illustrated works. The entire book is presented as a series of highly developed and detailed borders featuring the poems of Robert Louis Stevenson.

Dozens of activities and adventures fill the borders and effectively capture the inventive and joyous aspects of childhood. Each composition is expertly developed for the poem it illustrates, and the details are rich and varied.

The Land of Nod, p. 23, A Child's Garden of Verses, 1981.

North-West Passage, p. 42, A Child's Garden of Verses, 1981.

All for Love appeared in 1984 and is an exquisitely conceived and presented ode to romantic love as well as love of family, friends, pets, and life. The book celebrates love, requited or not, as a necessary and enjoyable human emotion. Tasha's art touches on the tragedies of life, too. While the book is filled with couples clearly enjoying each other's company in a romantic context, Tasha doesn't hesitate to include a grief-stricken man, whose love has died, holding his head in despair, as well as a desolate scene of a tiny sparrow lying dead upon a grassy grave.

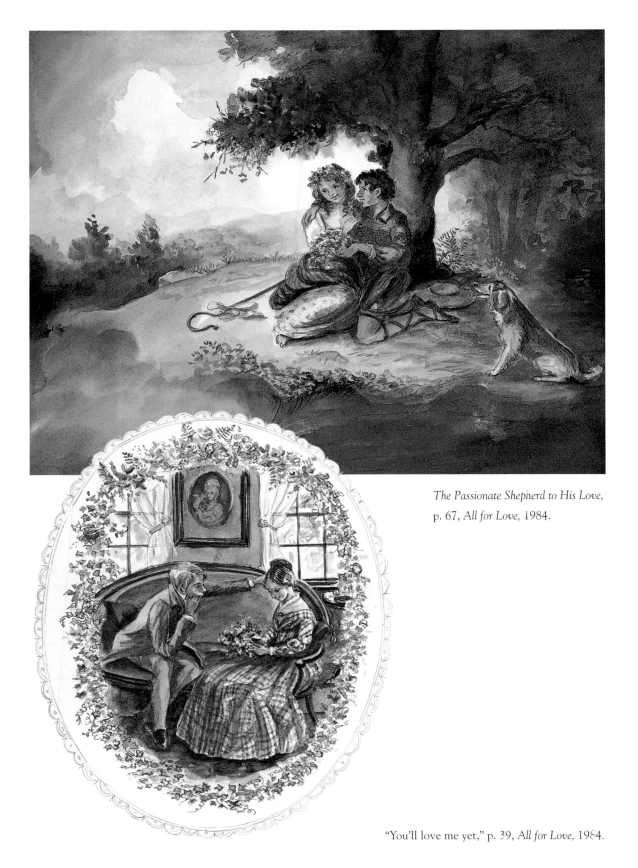

The Passionate Shepherd to His Love,
p. 67, *All for Love,* 1984.

"You'll love me yet," p. 39, *All for Love,* 1984.

It is the combination of the romantic and the darker sides of life — desertion, unrequited love, and death — that distinguishes Tasha from so many other illustrators. She is completely capable of presenting the world as she wishes it to be, but she retains an understanding and acceptance of how it often is. It is her ability to live the fantasy and keep a careful eye on the reality that makes her art believable and makes the life she envisions seem obtainable.

An interesting series of unpublished sketches offers exquisite witness to Tasha's mature skill with a pencil. Done originally for a never published book that evolved into *All for Love*, they show her consummate ability to capture nuances of expression and emotion.

Pencil sketch for unpublished forerunner of *All for Love*. This sketch was redone as a watercolor for p. 39, "You'll love me yet."

The watercolors some of them would inspire are excellent in their own right, but the pencil drawings have a special appeal.

All for Love contains one of Tasha's unique valentines, consisting of an arrangement of terracotta flowerpots filled with a variety of blooming plants. Each flower, when pulled from its pot, reveals an expression of love or goodwill where its roots would normally be. Tasha's imaginative valentines were available commercially on a very limited basis, and were highly prized among family and friends. Dr. Cupid Corgi is one of her recurring characters and is usually pictured in his laboratory concocting love potions. Bogarts, her whimsical creatures from *Corgiville Fair*, are another favorite valentine theme.

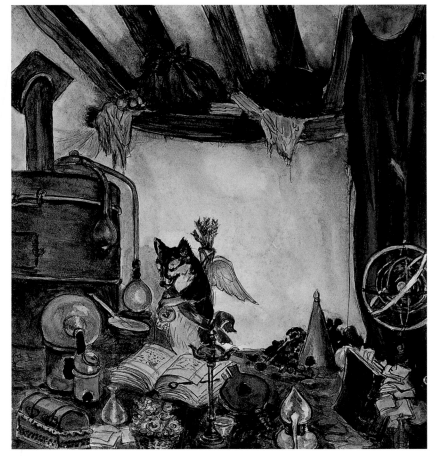

Valentine. *Dr. Cupid Corgi in His Laboratory.*

Valentine. *Love's Prescriptions,* 1973.

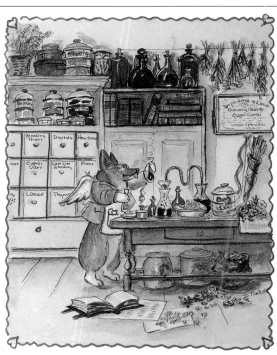

Advent calendar, 1978.

Advent calendar, *The Days Before Christmas*, 1980.

Tasha Tudor's Advent Calendar (1988) allowed Tasha to return to Corgiville and present one of her Advent calendars in book form for the first time. The actual calendar shows the citizens of Corgiville celebrating Christmas in the town square. Brimming with activity, it is one of her most exuberant expressions of life among the creatures she so admires.

Tasha's Advent calendars are among her most creative idealizations of life peopled by animals, gnomes, and bogarts. She originally created them for her family's use, and they were seldom seen until Rand McNally began publishing a series of them in 1978.

Several show wintry scenes of the forest at night, busy with ice-skating foxes, gnomes riding wolves or gliding through the air on white geese, rabbits playing violins while mice dance, and top-hatted crows greeting their friends. This enchanted world is dramatically enhanced by the life going on beneath the forest floor. Each calendar is divided into two sections, above- and below-ground. Underneath the pleasures of the bleakly beautiful snowscapes, a world of homey warmth exists in the burrows of rabbits and raccoons. Their homes are extensively furnished with the same antiques and furnishings, Tasha's own, that she has used in her illustrations for more than half a century. The familiar Canton china, blue-decorated stoneware, copper pans and baskets, Tasha's cast-iron cookstove — all are present. The larders are full and celebrations abound. With still more worlds within worlds, tiny mice inhabit burrows beneath the larger ones, equally well appointed. The cut-out doors, which are to be opened one at a time during the Advent season, are filled with greetings or depictions of animals bearing gifts or expressions of goodwill. Artistically and creatively, they are Tasha at her best.

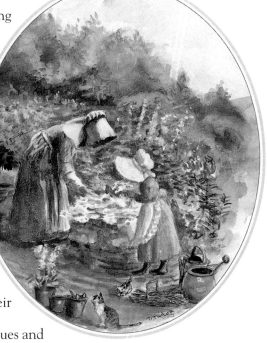

"We should not mind so small a flower —,"
p. 17, *A Brighter Garden*, 1990.

p. 29, *A Brighter Garden*, 1990.

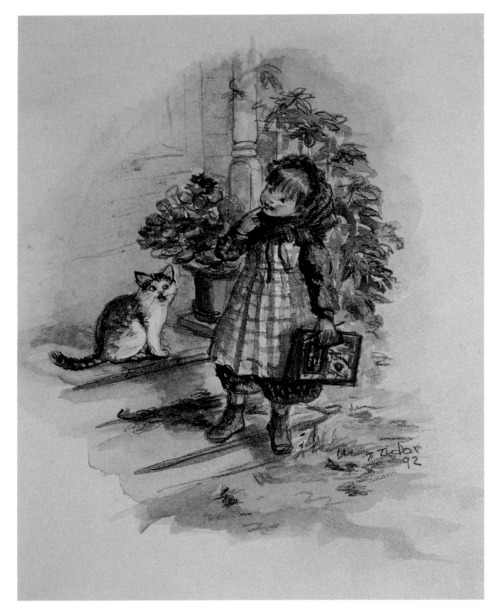

Title page, *The Real Pretend*, 1992.

A Brighter Garden, in 1990, and *The Real Pretend*, in 1992, are the last two books Tasha produced before she began a rather extraordinary new stage of her career. *A Brighter Garden* contains a selection of poems by Emily Dickinson, whom Tasha greatly admires. Her serene illustrations of New England landscapes show the same deep respect for nature evident in the poems.

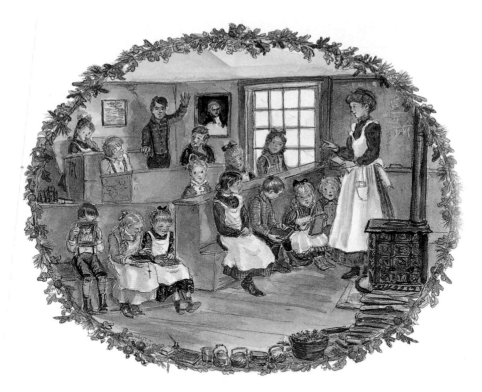

"Then it was Monday — Kathy's very first day of school," *The Real Pretend,* 1992.

The Real Pretend was not widely distributed, and has yet to be reprinted, so many of Tasha's fans remain unaware of the beauty of its illustrations. Tasha's mature style is evident here, and the page borders are simple but integrally related to the nostalgic feel of the story itself.

With the publication of *The Real Pretend,* Tasha had produced more than eighty books in fifty-four years. She had felt some type of summation, and a rest, was in order. She collaborated at great length with photographer Richard Brown on an intimate look, in words and photographs, at the highly original life she had created for herself. It was intended to be a graceful, final recording of that lifestyle. Instead, it generated a phenomenon that would dramatically alter her life.

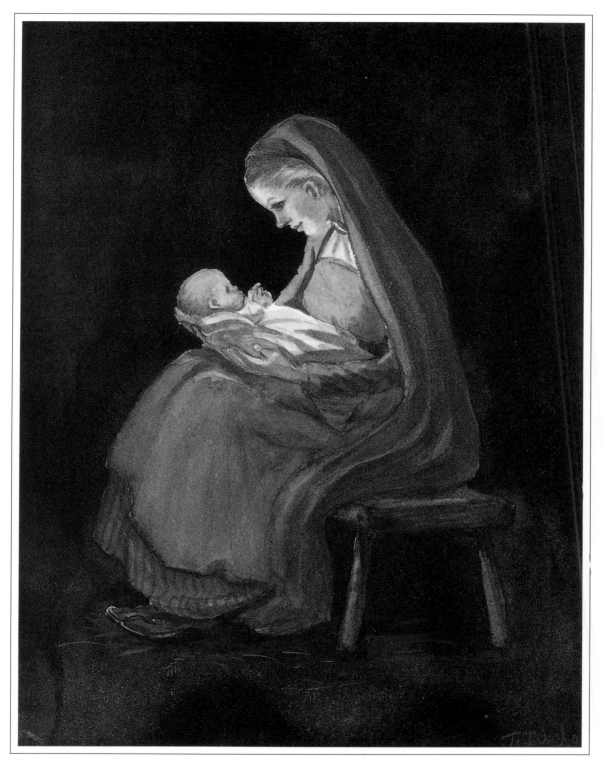

Take Joy! The Tasha Tudor Christmas Book, 1966; also published as a Christmas card
and, later, as the print *Madonna in Blue.*

LOST ART

Tasha is enormously critical of her art. She really doesn't consider herself an artist, but rather an illustrator. In the period in which she grew up, the distinction constituted a real divide; artists were taken seriously, illustrators were for hire. Tasha has the greatest respect for artists and regards her mother as one of the best. Although Rosamond Tudor's art did, on occasion, appear in popular magazines, she wasn't commercial in the sense that illustrators of the time were. Her main focus was on portraits, and one of Tasha's favorite paintings is of her brother, Frederic, which her mother painted while he read. Rosamond Tudor was extremely gifted and her portraits hang in a number of institutions and museums, but she never achieved anything close to the popularity and celebrity of her daughter. It is an ironic footnote to how the daughter views her own art in comparison with her mother's.

Tasha usually says that she has only five paintings that she's proud of. Her favorite is also the best known of her work. *Laura in the Snow,* painted in 1978 for *Springs of Joy,* is a bold, delightfully simple portrait of her granddaughter Laura walking on snowshoes, accompanied by two black cats.

The daughter of Tasha's daughter Bethany, Laura lived with Tasha for a period and was one of her favorite models. She remained Tasha's only granddaughter until son Tom and his wife, Eun Im, produced Hanna Tasha, long after Laura grew to adulthood. Even today Laura, as well as Tasha's other grandchildren and children, continue to be painted at the point in their lives when Tasha remembers them most vividly. Should she need help capturing a particular pose, Tasha goes to her dozens of sketchbooks containing thousands of drawings. "In my sketchbooks, my children and grandchildren remain children forever."

Using her children as models forced Tasha to learn to draw and paint rapidly. "You get used to children moving quickly — you must get them down on paper as quickly as they move. You may see them in a delightful position and you want to capture it immediately because they might never do it again." Tasha's practice paid off, and never to more effect than with *Laura in the Snow*. Painted in only thirty minutes, it once hung in the Metropolitan Museum of Art in New York City and now has a place of honor in the parlor at Corgi Cottage along with another favorite, *Madonna in Blue*.

Tasha's third favorite is *Winter at Corgi Cottage*, which she gave to her son Tom for Christmas the year she painted it to be produced as a print for Corgi Cottage Industries. While the remaining favorites on her list sometimes vary, the fourth spot on her top five list is usually *Old-Fashioned Roses*, also created to be one of our prints. It hangs above her art table in the winter kitchen. Frequently last on the list is Caleb Corgi at his desk, from *The Great Corgiville Kidnapping*.

These favorites she regards with a near reverence because she realizes that she accomplished exactly what she wished to do. Everything else she has produced, in her words, is often "quite nice" but not exactly what she hoped it would be.

Tasha has a long history of burning paintings she doesn't like. Even when she desperately needed the money they would bring, she was somewhat ruthless in destroying them. She never considered how marvelous they were to everyone else, only how they compared in her eyes with the artist she wished to be. Her habit was to hide them away until the pressure built up and then

Tasha's Old-Fashioned Roses. Published as a print, this watercolor is one of Tasha's top five favorites of all the work she has created during a career spanning more than six decades.

release herself from self-criticism by building a fire in the fireplace and committing them to the flames. Thankfully, because she isn't very organized and is not a fastidious housekeeper, they would often disappear into piles of other things and be granted a stay of execution.

I had long been horrified at the thought of what had been lost so casually. As one of my first assigned projects at Corgi Cottage, I was to become an unwilling participant in what was probably Tasha's last extensive destruction of art that displeased her.

My friend Lee Nichols and I had gone to Corgi Cottage for a weekend, and as it was rainy and gloomy, Tasha decided that a bit of housekeeping was in order. She also wanted me to assess what originals were left for sale and to organize and appraise them.

Portrait of Seth. This oil portrait of Tasha's son Seth, like the companion portraits of her three other children, Bethany, Efner, and Tom, was destroyed by Tasha because she felt it to be below her standards. Particularly in portraiture, Tasha tends to compare her work unfavorably with that of her mother, the renowned portrait painter Rosamond Tudor. The small bogart sitting in the chamberstick bowl was the childhood gift to Seth that inspired the lively bogart inhabitants of Corgiville.

It soon became apparent that there were a great many more than she or I had anticipated. They were everywhere. At one point, to my shock, as we pared down a mound of paper in an upstairs hall corner, I looked down and saw my feet firmly planted on two original watercolors.

A lot of trash was disposed of, and then we got down to serious business. I had hopes of preventing what I knew she intended to do, but I was only partially successful.

Tasha sat on the bed in the winter kitchen after having added wood to an already impressive fire. Lee stood between her and the fireplace, ready to take whatever Tasha handed him to throw into the fire. I hovered, nervously, debating with myself as to what I should — or perhaps more important, could — do. Tasha takes advice infrequently, at best. To attempt to intervene with one of the world's more revered artists on behalf of her own art would be a rather foolish act, but I knew the day would haunt me if I didn't at least make the attempt.

The process was swift. She knew immediately how she felt about each piece. She tried to be polite, yet was mostly unmoved by what I thought. Each time she handed a drawing or watercolor to Lee, our eyes met and I would nod before he tossed it in. Early on she handed him a major piece, and I shook my head. Tasha looked at me, and her eyes flashed. We each held our ground until we both began laughing. Lee started what would become a small, hard-won pile of saved watercolors Each contested piece had to be debated, and I was thankful that I could successfully defend why I thought the work was better than Tasha judged it. Years of studying her art paid off that afternoon. I lost on a number of still-remembered paintings. In fact, a small fortune went up in flames in the very fireplace that is, arguably, the most painted fireplace in the history of art. There was nothing to do but let her have her way. She was Tasha Tudor and it was *her* art; I said that to myself over and over, almost like a mantra, each time a piece burned.

Tasha was enjoying herself. She was winning much of the time, and when I was successful, she was flattered that I thought so much of the work. Lee offered opinions as the afternoon wore on and Tasha listened carefully. Sometimes she was won over by his petition, sometimes by mine. We both groaned as a well-executed oil portrait was handed to him with an emphatic "No arguments. Now!" We were still doing the eye-and-nod check, but I knew she meant it and I nodded quickly. Tasha's oil paintings are quite rare, and she's far better than she gives herself credit for I felt helpless, and the painting seemed to take forever to burn.

Both Tasha and I had a satisfying win by the end of the day. A small oil painting of a cat was handed to Lee and I lunged for it, taking it from both their hands. "Absolutely not. There's no

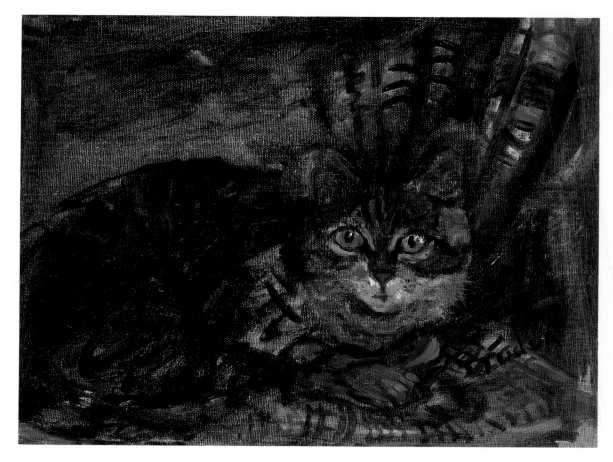

Puss. This oil portrait of Tasha's cat was almost burned during Tasha's last extensive
destruction of paintings. Tasha's habit of destroying paintings has more basis in
insecurity than in the relative merits of the paintings involved.

discussion about this one. None!" I immediately felt mortified by my outburst and feared that I
had gone too far, completely overstepping my boundaries, but Tasha was impressed. "I'm sure Puss
is grateful to you. See that you give her a good home." Puss would be locked in my car when we
finished. After the previous few hours, I had a healthy fear for the safety of anything Tasha had ever
painted.

Tasha's most gleeful moment came at the expense of the illustration from page 54 of *Tasha
Tudor's Cookbook*. Tasha had conceded the previous three originals to Lee's saved pile and was
tiring of the process. She leaned around Lee and tossed the small watercolor with great accuracy

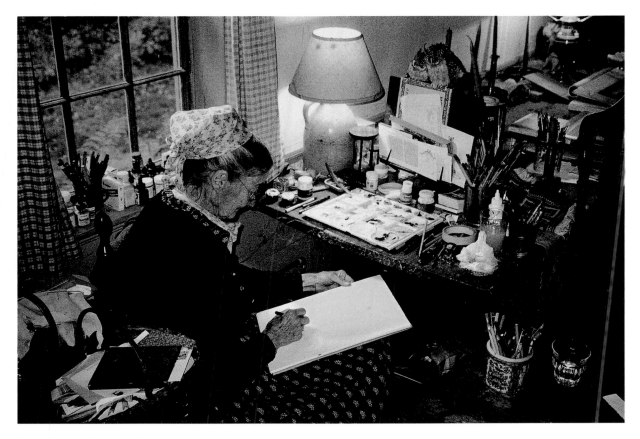

Tasha Tudor at her art table.

into the center of the fireplace. "Tasha, that's a published piece. Everyone has already seen it,"

I said. I was growing equally tired of the destruction. "It started out as a roast," she replied, evenly.

"It was never meant to be a turkey. Now it's nothing." She shrugged and then smiled. "Besides, a

turkey *should* be placed in a fireplace."

We finished as darkness fell, and I had seldom been so exhausted. Lee felt the same way. He

retained a quizzical look he had had for hours. All the lost art kept flashing before our eyes, and I

was justifiably nervous about the safety of the surviving pieces. Tasha was elated at the progress.

"How nice to have all that trash disposed of," she said gleefully as she went out to milk her goats.

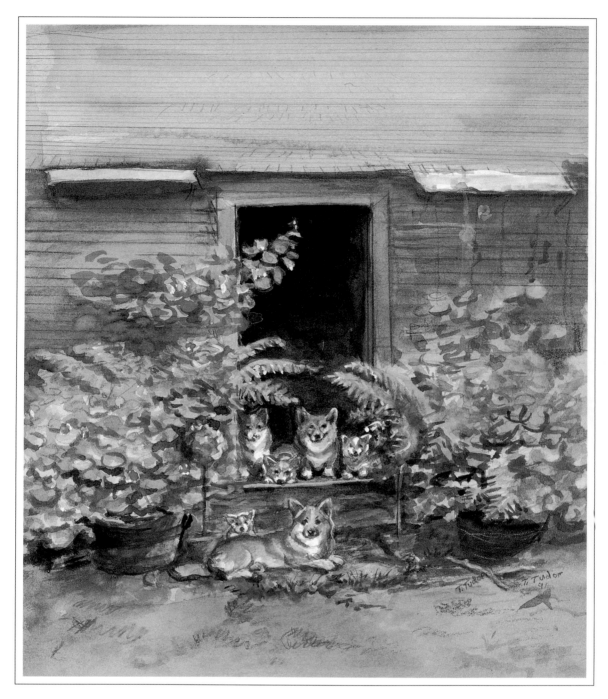

Family Portrait, published as a print, 1997. Tasha's last litter of corgi pups pose at the back door to Corgi Cottage. On the doorsill are, from left, Winslow Homer, Caleb Bingham, Rebecca (the doting mother), and Andrew Jackson. In the foreground, from the left, are Benjamin Franklin and the proud father, Owyn.

THE ARTIST AS CRAFTSPERSON

Many artists prefer to practice their craft in private, and Tasha is no exception. Once her children were grown and she could exercise more choice in her work, she generally painted in the winter, when three feet or so of snow provided her with a delicious isolation from the rest of the world. Time at Corgi Cottage stands still in any season, but never more so than in the winter. Days have only the structure one truly desires to give them. The animals are fed on schedule, and the fireplace and wood stove are tended; everything else takes on a languid pace of its own. Ideally, this is when Tasha paints, preferring to immerse herself in her garden in the spring, summer, and fall.

In the fall of 1996 we found ourselves in a pressured situation. Tasha had talked for years at public appearances about a "smashing sequel to *Corgiville Fair*," her favorite book. She always promised that it was nearly done. In fact, in twelve years she had written the story but had produced only one illustration. As part of the revitalization of Tasha's career, I had secured the services of a top agent and we negotiated her largest advance, for publication of *The Great Corgiville*

Kidnapping, the long-awaited sequel, and a new edition of *The Night Before Christmas.* Tasha had been enthusiastic at the time, but she failed to begin work on the project. I was to learn that this was a deeply ingrained, lifelong characteristic.

We were quite involved with the selection and preparation process for the upcoming exhibition at the Abby Aldrich Rockefeller Folk Art Center in Williamsburg. It had involved many pleasant but time-consuming visits from the curators, whom we had come to consider friends. Tasha flirted with the idea of actually moving to Williamsburg, and to test the potential of that possibility, as well as to provide final help with the exhibit, we spent the month of July in a cottage in Williamsburg. The visit was an exhausting round of meetings, social engagements, and nonstop visitors. Tasha found it wearing and far too great a change from her normally controlled environment. I found the challenge of trying to keep her happy somewhat overwhelming. The absurdity of it all was crystallized for me when I overheard my assistant on the phone to a local supermarket. He was trying to have them page a friend who had been sent grocery shopping. They were apparently reluctant to page anyone until I heard him say, "Of course it's an emergency. Tasha Tudor wants more broccoli." It was definitely time to go home to Vermont.

Tasha was delighted to be back at her beloved Corgi Cottage, but we faced a serious problem. The deadline for the book was only a month away. I was well aware that creativity such as Tasha's cannot be scheduled, so I had resisted pressuring her, but a major deadline was now at hand.

Prior to our forming Corgi Cottage Industries, Tasha had considerable laurels upon which to rest. Her achievements and reputation were already legendary. Both she and I wanted more, however, and, together we had carefully crafted a master plan to reinvent her yet one more time. The exhibition, due to open in less than three months, was the major component. The other was the new book.

Tasha and I had a serious conference. I emphasized the implications of failing to deliver the art on time. Bluntly, I reminded her of her reputation among publishers for being both late and difficult to work with. It had been a sticking point in the negotiations of the contract. She had heard it

Cover, *The Great Corgiville Kidnapping*, 1997.

all before and was not pressured in the least. I reminded her of the payment due upon receipt of the completed art, and she immediately focused on the problem. Money is a significant motivating force in Tasha's life. She will readily admit that "had it not been for the wolf at the door, I would never have had a career. I would have just sat around making paper dolls." Raising and educating four children had been extremely expensive, and for many years Tasha had no choice but to take every project that came her way. Her originals were sold for whatever she could get as soon as they came back from the publishers. The years of constantly scraping for every dollar have left their mark on her. Even though she is now far past need, she well remembers how difficult it was for her and can work as hard as if the need were still there.

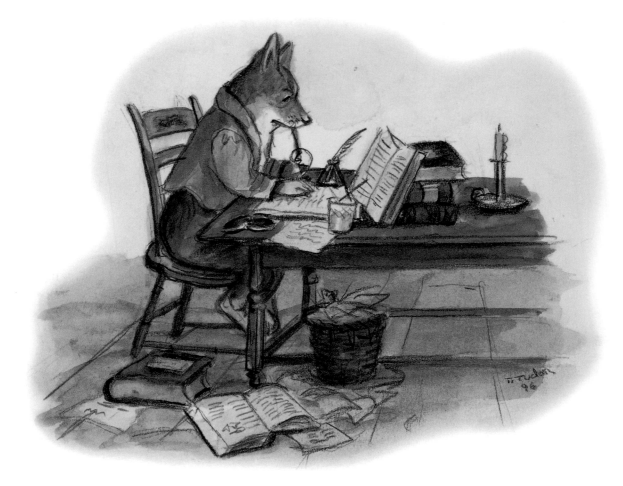

"It was July, and Caleb was writing a scholarly paper on 'The Relationship of Common Scents to Crime.'" *The Great Corgiville Kidnapping, 1997.*

Tasha flashed one of her characteristically impish smiles at me and said, quite casually, "You know, all is not lost. I can still do it."

I was incredulous. "In four weeks, you can paint forty illustrations?"

"Well, I'll need a bit more time and a great deal of help. You do your job, and I'll do mine."

The next five weeks were an astonishing look at the creative process of a mature artist who had honed her skills over nearly three-quarters of a century. I managed to get a week's extension from Tasha's editor. I'm afraid I lied about how far along she actually was.

The plan was for Tasha to do very little except paint. The only tasks she refused to trust anyone with were the feeding and milking of her goats. Everything else was to be assigned to someone. It sounded far more simple than it proved to be.

The young man who occasionally did heavy work in Tasha's garden was engaged to tend the garden entirely. This was a major concession on Tasha's part because she truly enjoys the work and has a strong spiritual tie to her plants. She can be in the house and suddenly know that a particular plant is in urgent need of water. To help her maintain her sense of control, the young gardener was briefed each morning by Tasha before he began.

I hired a cook to take care of meal preparation. Another major concession. Tasha doesn't like anyone's cooking except her own. She is especially unforgiving of anyone else attempting her recipes. Whenever we traveled, she would prepare her food in advance and take it with us. The fact that I could consume, and often relish, room-service meals astonished her. This cook would be quite challenged. Recipes similar to but not exactly those in the *Corgi Cottage Cookbook* were tried and were sometimes well received. Often Tasha was so absorbed in painting that she took little notice of what was served.

A number of guests had been previously scheduled, including the Williamsburg curators who were picking up all the objects being loaned for the exhibit. I knew that if I left the house, Tasha would be interrupted, so I stayed close by, supplying her with whatever she needed and keeping everyone at bay. I added an assistant to run errands, which brought the staff to four, including me.

In order to accomplish what this one seemingly frail woman usually did all by herself, the four of us never stopped working. Lists were done each night for the next day, and analyzing all the details that were important to Tasha provided great insight into her life. Vegetables had to be picked just prior to cooking, herbs only minutes before use. A great many things had to be shopped for each day, because everything had to be as fresh as possible. The garden's care required a complex list of what each plant needed, and I marveled at how simple it all seemed to Tasha.

My hands were often quite full supplying Tasha with what she needed to paint. Details of knots used in ballooning proved quite troublesome. Each time I would go to the library or bookstore, someone would interrupt Tasha's schedule. Finally the cook became guardian of the door to the winter kitchen, where Tasha worked.

To watch Tasha work was an extraordinary privilege for me. I had seen her paint, of course, but to watch her work from beginning to end, on an entire book, was something I hadn't dreamed of.

Tasha is amused and a bit perplexed by artists who have studios. She grew up under her mother's easel and entertained her models by reading to them, so she is no stranger to the proper accoutrements many artists need. She requires far less than most. Only when painting large oil portraits does Tasha use an easel. Her entire studio consists of a few feet of space on the end of her long harvest table. A bookstand displays art in progress, but she usually paints flat, taping her watercolor paper to an old artist's board, often the back of an unfinished portrait or one held in low esteem.

She surrounds herself with an untidy array of brushes, ink bottles, and wadded tissues used to daub paint. Fresh flowers are always close to her palette. Antique artists' boxes, some of which belonged to her mother, are stacked high enough to hold the baskets filled with correspondence and catalogs. The effect is very much like a tiny mouse in its nest. Leaves, acorns, or whatever has caught her interest outside are scattered about, often mixed in with buttons and sewing accessories. Tasha is very tactile in her painting habits, preferring to see and touch what she is painting. She paints relatively little from imagination and adamantly disdains painting from photographs. "The camera has seen your subject, not you." She uses photographs only when absolutely necessary. "One has to make exceptions when painting tigers and such," she concedes reluctantly.

The lengths to which Tasha will go to secure accuracy in her work was never more apparent as the time drew near to paint the raccoons in *The Great Corgiville Kidnapping*. They are the villains of the book, and Tasha was a bit reluctant to tackle them because she hadn't painted one in years. Each afternoon at tea we would discuss the next watercolors and what needs they might present. If the painting included Caleb Corgi's Liv-A-Snaps, a box would be sent in from somewhere.

"'However did you manage to shut yourself inside there?' asked Caleb."
The Great Corgiville Kidnapping, 1997.

"Caleb's next stop was Megan's Market." *The Great Corgiville Kidnapping,* 1997.
Many of the signs and advertisements in *Corgiville Fair* and *The Great Corgiville
Kidnapping* make reference to friends of Tasha's.

Tasha's faithful FedEx delivery man, Ray, came every day. Some items or bits of information proved quite elusive, and I often spent hours tracking something down.

Tasha kept avoiding painting the raccoons until a most fortuitous event occurred. An intruder began appearing at night, knocking over things and raising the ire of Tasha's *corgyn,* which weren't allowed out after dark but always alerted us to any unusual visitors. Tasha called a friend for a trap and set it herself, directly in front of the window she paints at. The next morning she jubilantly announced that she had her model. An absolutely chagrined raccoon glowered at me from his cage atop Tasha's small tea table, which has been in daily use since nursery days.

The local shepherd who had supplied the trap was skeptical when Tasha called to tell him she had been successful. He confided to me that there had been an unusually high rate of rabies among the raccoon population that fall and that he was coming to pick up the intruder immediately. Tasha refused. "He's going to pay for his crimes by modeling for me," she insisted, and that was that.

The next day and a half were a nightmare. Both the cat and Rebecca and Owyn, Tasha's *corgyn,* were thrown into abject terror. Minou, the cat, simply disappeared. The *corgyn* had to be banished and were extremely vocal about their displeasure. The captive model vacillated between sleeping and expressing aggressive anger at his confinement. I alternated between elation that she had her model and fear that she would be attacked. Tasha was as calm as if the raccoon were being paid by the hour and grateful for the job. Even when she is painting under pressure, she doesn't hurry. She studied that raccoon, talked to him, and sketched him over and over. His fits of anger were timely as she painted the kidnapping villains resplendent in their evil. That night he was relegated to the parlor. I slept fitfully, sure that both my safety and sanity were about to be compromised.

The concerned shepherd arrived the next morning. Enough was enough, he said; he had come for the raccoon. It was too dangerous. Tasha was her most coy. Of course, she said; only a bit more time was needed. In the meantime, however, the goats seemed vaguely unwell, and if he would

"The raccoon let out a yell of rage, lost his grip, and fell, crashing down upon his mates below, who had already been closing in for the kill!" *The Great Corgiville Kidnapping,* 1997.

only look at them, she'd be so reassured. He complied, knowing full well the rules of the game. Tasha dashed to her worktable. "Feed him cookies, anything. I'm not done yet."

I stood outside the door when he returned. Our eyes met with the dismay two grown men feel when both know they have no control whatsoever in the face of feminine resolve. I offered the plate of cookies, and we silently munched. Soon after, Tasha emerged pleasantly from the winter kitchen and thanked him for escorting her visitor off the property. She recounted one of her favorite stories about the local man who had bragged about capturing more than forty raccoons and taking them to the next town, only to discover later that it was the same hapless raccoon he wasn't taking far enough away. "I think that raccoon had just come to enjoy his nightly ride." she

laughed. I have seldom felt as much relief as I did when the truck pulled away with the soon-to-be-immortalized raccoon.

Progress on the book was recorded each night in Tasha's artist's dummy. Her method of drawing and painting is simple and predictably old-fashioned. She first draws her image on tracing paper, expanding and correcting it until she is completely satisfied. Holding her pencil at a 45-degree angle, she then covers the back of the drawing with a heavy coat of graphite, creating a homemade carbon paper. She is then able to transfer a line drawing of the image onto the expensive watercolor paper by simply retracing the image. This avoids having to make corrections on the paper itself and altering the surface the paint will be applied to, which would, in turn, alter the consistency of the paint. The method is ingenious and allows Tasha to keep a record of her work, and occasionally reuse an image. This accounts for the similarity often seen over the years in her work. A child drawn for a Christmas card in the 1940s may reappear, slightly altered, on a print in the 1990s. For each book, Tasha makes a dummy, including text, and as she completes each watercolor, the pencil tracing is put in its appropriate place. In the past this dummy would be given to the publisher as a guide to placement of the illustrations.

Taking advantage of the advances in color laser printing, I made an additional publisher's dummy in color with the text typeset. This enabled Tasha to see exactly how the finished book would look, and she was delighted.

With minor mishaps, the work was proceeding well. Tasha cautioned me repeatedly that her editors should never be told how fast she could paint when necessary. With few, if any, books still to come, I think the secret can now be safely told. In fact, Tasha doesn't credit herself with all the time she spends mentally preparing to paint, while putting off actually doing so. The creative process certainly combines both mental and physical exertion, and it would be difficult to adequately calculate the former. Even so, I was amazed at her output. Near the end, it was as if she couldn't stop. She did far more pieces than the contract called for, sometimes several versions of the same illustration. Twice during the final week, Tasha produced as many as three illustrations a

day. The morning we left for Boston to deliver the art, she was still painting. As I stopped to make the final color copy, I had concerns about whether the paint was actually dry enough to survive the copier. Fortunately, it did.

The book was delivered on time, albeit on an extended deadline. It is handsome, but not the equal of its predecessor, *Corgiville Fair*. Tasha had simply waited too long to do it. Her style had changed and was no longer as simple and fresh as when she first envisioned Corgiville. Age had intervened and Tasha's eyesight wasn't as good as it had been twenty-six years earlier. She will not acknowledge any loss of vision, and the problem is made far worse by her refusal to wear prescription glasses. She insists on wearing antique glasses, which look charming but do little to correct her vision. The dark murkiness of the illustrations in *The Great Corgiville Kidnapping* is apparent and regrettable. When paired with *Corgiville Fair*, however, they represent an impressive achievement.

Combining and adapting the best of the influences Kate Greenaway and Beatrix Potter had on Tasha's development as an illustrator, the Corgiville books constitute one of Tasha's greatest creative accomplishments — a unique world where all inhabitants get along or at least tolerate one another and where the best of human traits are taken a bit further by creatures who may, in fact, be quite superior to us. Tasha is fond of quoting Oscar Wilde's "I think God overestimated his abilities when he created man," and she frequently expresses her own low opinion of humanity. Corgiville may have been her attempt to create a better world. Its inhabitants still have free will — they can be decidedly wicked if they choose — but there remains a childlike innocence about them not unlike that of their creator.

Gingersnap. All of Tasha's corgis have served as models. Gingersnap was particularly appealing.

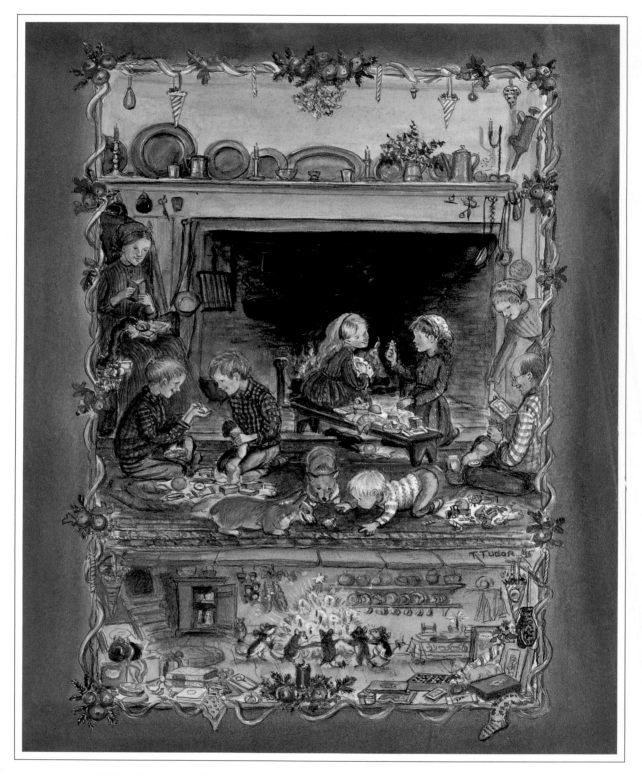

Tasha's Christmas Stockings, 1995, published as a print and as a card. The mice celebrating their Christmas beneath the floorboards is typical of the same technique used so effectively in Tasha's Advent calendars.

TAKE JOY!
THE WORLD OF TASHA TUDOR

The landmark exhibition of Tasha's art and life opened at the Abby Aldrich Rockefeller Folk Art Center in Williamsburg, Virginia, on November 6, 1996. The preview the evening before was prophetic regarding the reception the exhibition would receive over its five-month run. The preview guests, many of whom were longtime Tudor fans and therefore came with a great amount of prior knowledge about Tasha's career, were unanimous in their surprise at how much the exhibit covered. To see the amazing variety and depth of her accomplishments all expertly displayed and critiqued in a magnificent gallery setting made them marvel at how a single person could possibly have achieved it all.

Strangely enough, it had the same effect on Tasha. She had been reluctantly anticipating seeing the exhibition and finally decided she had to do so privately. After a year and a half of preparation, all the curators were naturally anxious for her approval. We had seen parts of it as the installation progressed during the week prior to opening, but when it was finished, it seemed daunting to Tasha to actually, finally review her life's work. Tasha and I went in alone. It was odd to

Winter at Corgi Cottage, 1996. Published as a print, this watercolor is one of Tasha's favorites. She has captured the delicate light and ethereal quality of snow in a masterful way.

Kitty in Kelo, p. 19, *Tasha Tudor's Heirloom Crafts,* 1995.

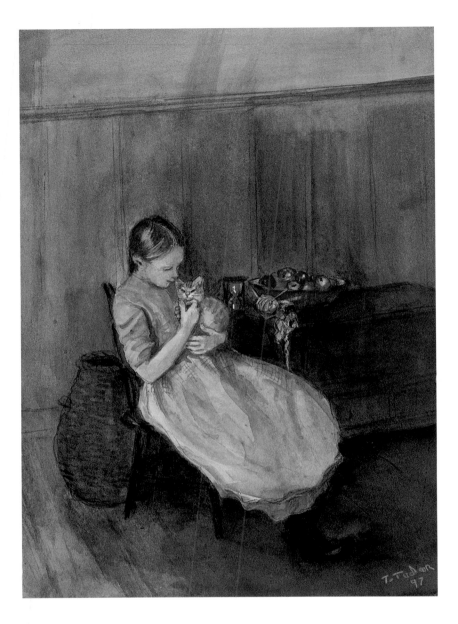

Contented Moment, 1997, published as a print.

have the curators waiting outside with eager enthusiasm — not actually doubting Tasha's reaction, because we had worked so closely with them, but desiring a final nod from her — and to be inside with Tasha, both of us somewhat stunned by the scope of the exhibit. Even though most of the objects were things normally in daily use at Corgi Cottage, their placement in glass cases made the familiar slightly intimidating.

Harry's Birthday, 1991, unpublished.

One of the strengths of the exhibition was its recognition that the art and the lifestyle were inseparable. An unprecedented amount of Tasha's art was displayed, and it was greatly enhanced by the presence of many of the actual pieces depicted in the paintings, including clothing, furniture, dolls, toys, baskets, china, weavings, Christmas decorations, tea sets, and kitchen implements.

Finally, Tasha let out a long sigh, and we began our tour. She actually read what was written about certain objects and greeted others with the same pleasure one would show an old friend after a long absence. In rapid succession she passed through the gallery rooms, nodding approval. She was delighted with what the curators had done but still somewhat uncertain about what it all meant. She looked at me with eyes as young as a child's. Her whole face seemed to take on that startling look one sees when an old face suddenly seems young again, when sheer enthusiasm and

spirit overcome age and wrinkles. She bubbled. "I've actually done it, Harry. I've made a success of it. I never thought I would, when I thought of it at all. No one else thought I would, either, you know."

We made the rounds once more, commenting on how much we had missed everything and how long it would be before they were returned to us. I missed my copper teapot, a gift from Tasha, which I used daily. It was quite unsettling to see the painting of me celebrating my birthday as a child, and remember there was an empty space on the wall by my bed where it usually hung. Tasha had done the painting as a birthday gift for me as an adult, but the likeness was uncannily accurate, even though Tasha had never seen childhood photographs of me. When I asked her about it, she was amused. "It's an instinct, I think. I drew boys and girls before I had my own children. The curious thing was that the children I drew in my first books were exactly like the children I had later on."

As the relationship with the representatives from Williamsburg had grown during the long period we had spent planning the exhibit, Tasha had become quite fond of everyone we worked with. They were given carte blanche to take anything they wished from her house. It was extraordinary to have such participation from a living artist in assembling such an extensive exhibition. It also ensured the accuracy of information and interpretation. They had only to ask Tasha.

Hooray for Christmas, 1993, plate design, also published as a card.

The Dove Cote, 1993, published as a print. This is the view seen from one of Tasha's bedroom windows. The doves are not only beautiful visually, but their cooing provides yet another dimension to life at Corgi Cottage.

Floral Sampler, unpublished.

Bouquet, unpublished.

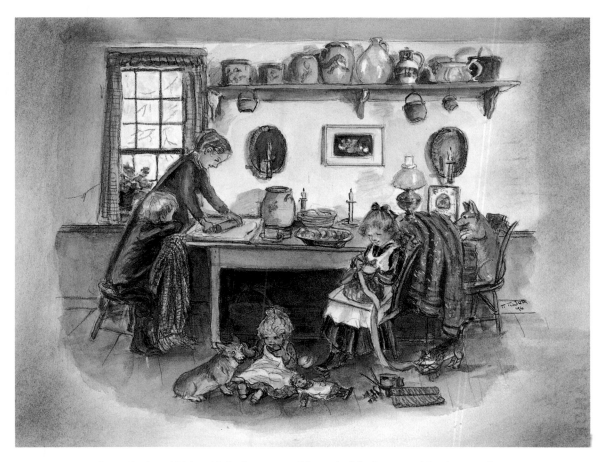

Sugar Cookies, 1996, published as a print. The end of the harvest table where cookie dough is being rolled out is where Tasha normally paints.

Farmhouse in Winter, unpublished.

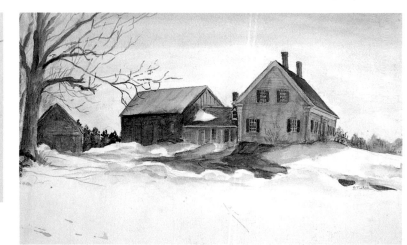

Botanical, p. 56, *The Private World of Tasha Tudor,* 1992.

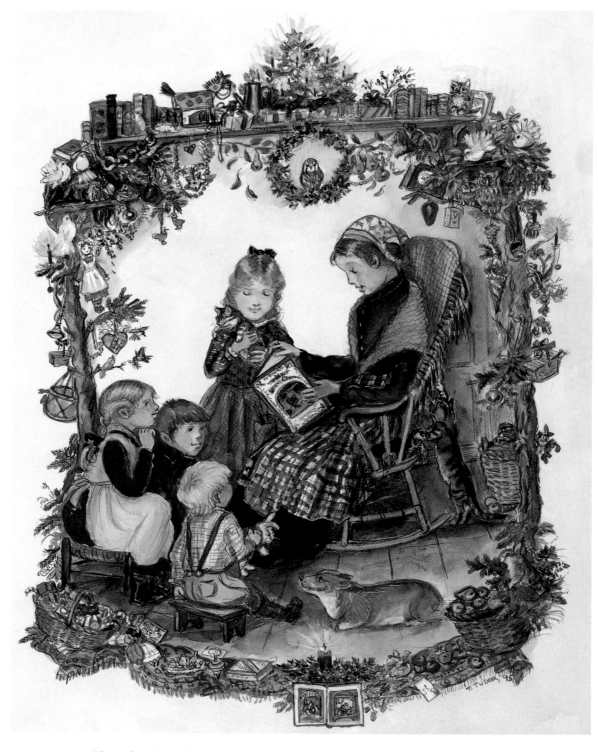

The Night Before Christmas, 1995, published as both a poster and a print. This classic Tasha Tudor image features a border filled with toys, gifts, and holiday treats. A young mother, wearing Tasha's own homespun apron and knitted tip-to-tip (shawl), reads from Tasha's 1975 version of *The Night Before Christmas.*

Still Life with Rose Hips, 1994, published as a print. This still life of rose hips from a Parfum de la Hay rose combined with a small blue-and-white vase sent by Tasha's son Tom, from Korea, is eloquent in its simplicity and reminiscent of the work of Old Masters.

Botanicals, unpublished.

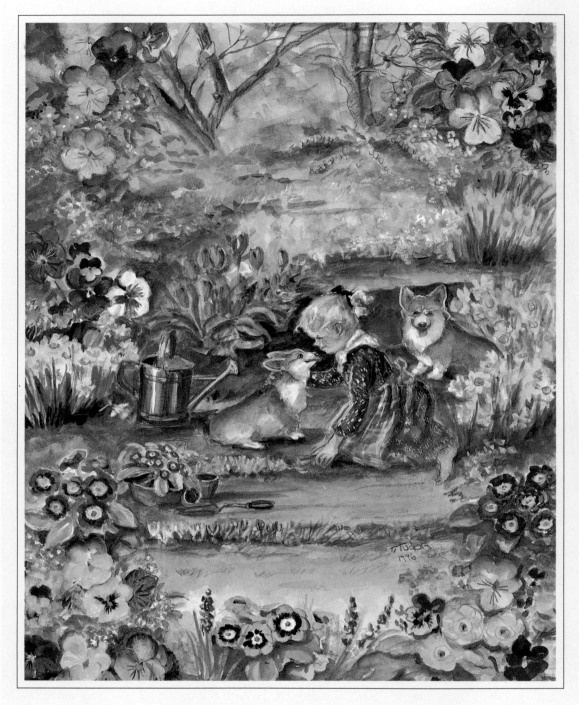

The Four Seasons. These four seasonal paintings were created for *Victoria* magazine in 1996 when Tasha became their first "artist in residence." The attention to detail and the use of vibrant colors makes this series extraordinary, and perhaps one of the better examples of Tasha's mature style.

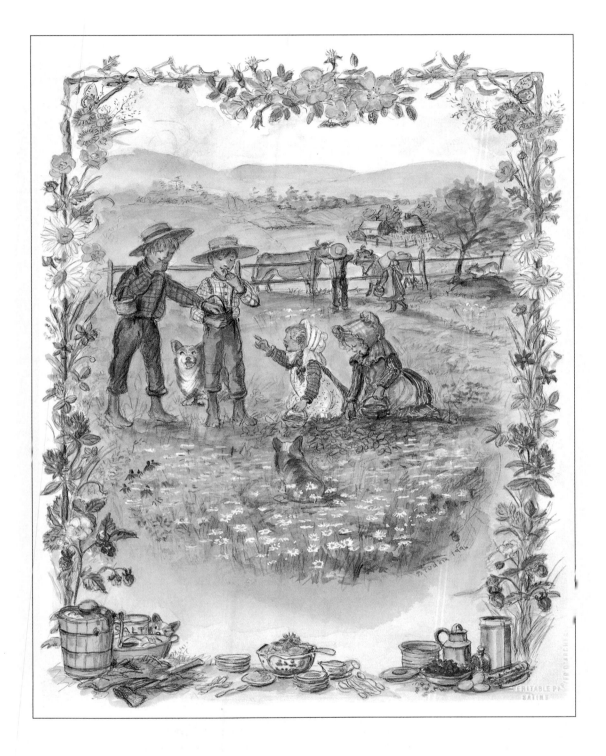

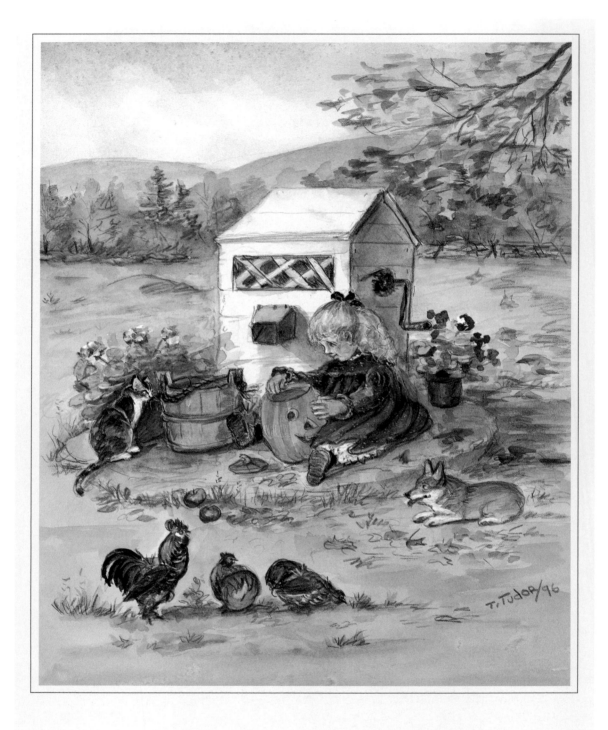

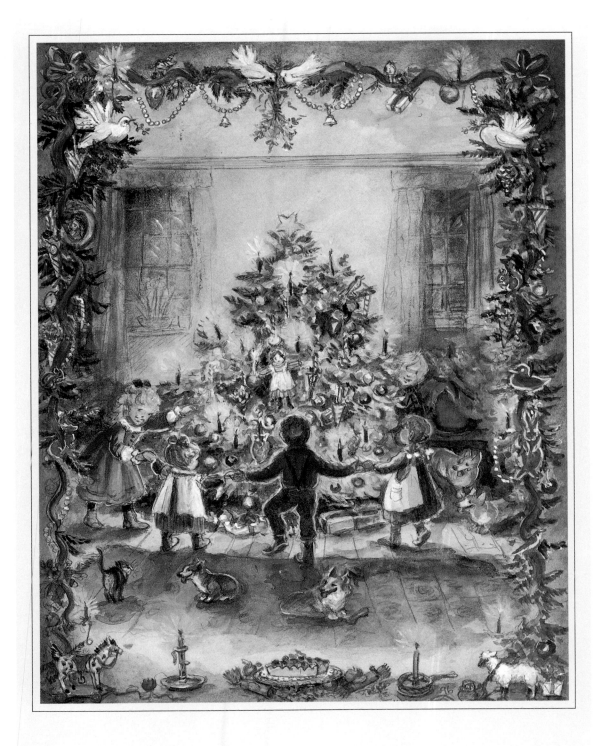

p. 88, *The Tasha Tudor Cookbook,* 1993;
also published as a card. Tasha has painted
numerous versions of her daughter Bethany
churning butter in one of her stoneware churns.

p. 98, *The Tasha Tudor Cookbook,* 1993.

p. 16, *The Tasha Tudor Cookbook,* 1993. The watercolors for her cookbook were
especially enjoyable for Tasha because she was able to paint familiar things she uses
daily in her kitchen, in this case, her hand-blown glass storage jars.

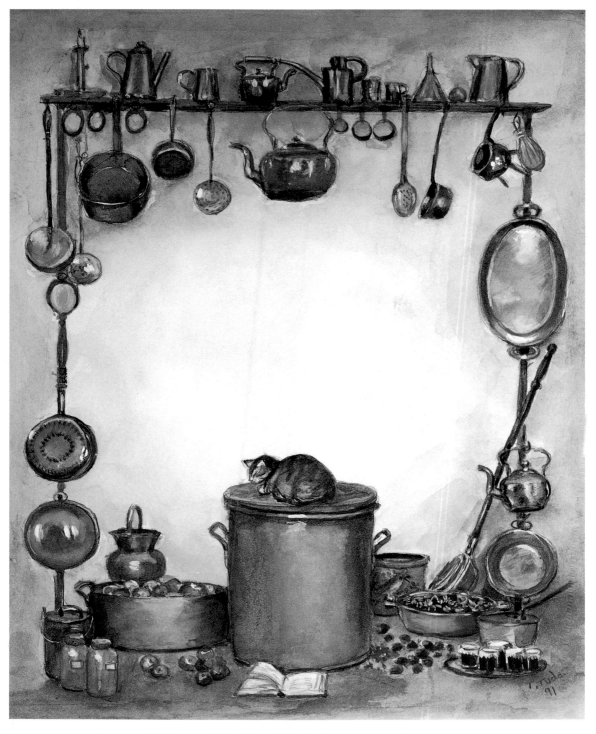

B-eads and Muffins, p. 23, *The Tasha Tudor Cookbook*, 1993. Tasha's extensive
collection of copper inspired this appealing and challenging border. The reflections
of the copper pots and pans are beautifully and skillfully executed.

p. 50, *The Tasha Tudor Cookbook,* 1993, originally published as a Christmas card.

Hot Chocolate, p. 95, *The Tasha Tudor Cookbook,* 1993.

p. 40, *The Tasha Tudor Cookbook,* 1993.

Robin by Candlelight, published as a print. One of Tasha's guest bedrooms is beautifully depicted here in the glow of candlelight. Tasha's subtle blending of reality and fantasy allows tiny mice families to go about their daily routines in each corner of the bottom of the painting.

Christmas in Corgiville, pp. 114–15, *The Private World of Tasha Tudor*, 1992; also published as a print.

Feeling more and more exuberant, she turned to me and said, with excitement in her voice, "It's smashing! Let's tell them."

She was past all doubt now, not just about the exhibit itself but her life as well. Now it was time to revel in her triumph. A remarkable few hours passed. The curators were jubilant; word quickly spread that Tasha was pleased, and throughout the building, there was a sense of relief. The guards smiled as Tasha thanked them for protecting her belongings. The atmosphere was festive as everyone connected with the exhibit had a moment with the creator of everything on display.

What it represented was one of the most extraordinary careers in children's literature with reverberations far beyond that genre. The difficulty in describing Tasha has always been that she doesn't fit into just one category of accomplishment. She wrote, as well as illustrated, many of her books. She retained her fans as they grew up in a way few, if any, illustrators have done, ever. It is one thing to remember one's childhood Beatrix Potter books and buy them, in turn, for your own children and grandchildren. It is quite another to continue buying Tasha Tudor books in adulthood for one's own pleasure.

After a long and renowned career in illustration, Tasha had become, in the words of one of her editors, "a member of the pantheon of the most prolific and revered illustrators of all time."

Bird in Winter, unpublished.

The Harpist, unpublished. This portrait combines many of Tasha's favorite things, including the white lace dress, her Canton garden seat (bottom shelf), and a strikingly handsome corgi.

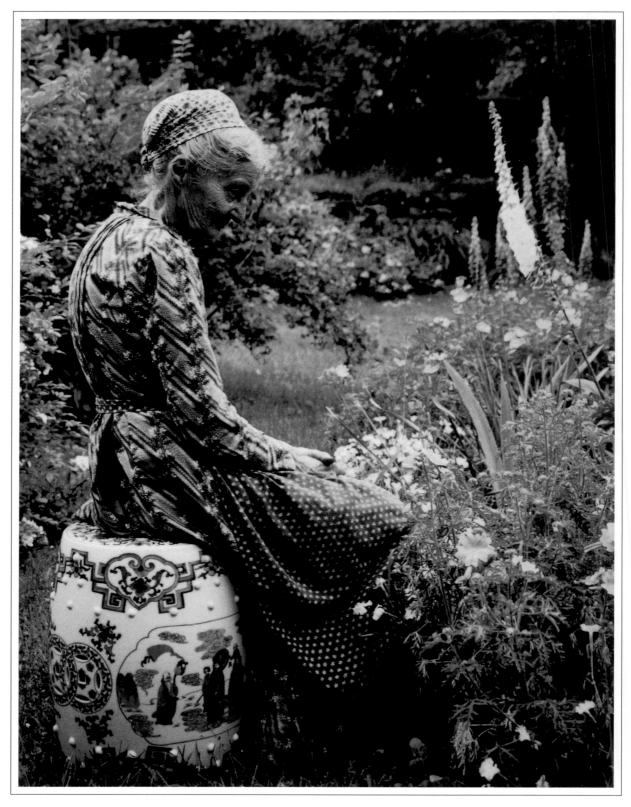

Tasha Tudor, 1998.

LIFESTYLE ICON

The Private World of Tasha Tudor, published in 1992, was extremely well received by fans eager to know more about the woman whose art they had so long admired. Instead of just a pleasant read, however, it became something of a lifestyle guide for people who wanted to reclaim or create a calm and beautiful place for themselves in the midst of a world often beyond their control. They identified with the grandmotherly side of herself Tasha presented, and they wanted to know more.

Tasha was elated at the interest in her generated by *The Private World*. In homage to her love of cooking and all the antique kitchen utensils she used daily, she produced *Tasha Tudor's Cookbook* in 1993, which contains some of her most painterly work. From the smaller still lifes of yellow ware bowls and kitchen implements, to the more complex renderings of her kitchen or the family enjoying Christmas dinner, she simply radiated control of both the subject and the medium she loved. The recipes, really her own, are excellent, and the watercolors make one immediately want to

The Children's Garden, 1995, published as a print.

gather ingredients and begin cooking. The comfortable feel of the book is of another time and place, and it added to the rapidly growing, and often intense, respect and adulation fans felt for her.

In 1994 *Tasha Tudor's Garden* was published, and Richard Brown's superb photographs made the gardens at Corgi Cottage look blissfully paradisical. Tasha was a great admirer of Brown's work — "He takes the most flattering photographs of older women!" — and enjoyed both the lengthy process of catching each stage of the garden at near perfection and the resulting book. It was enthusiastically received and was given the 1995 Award of the Year by the Garden Writers' Association of America.

Tasha Tudor's Heirloom Crafts followed in 1995, and Tasha had begun a snowballing process of acquiring new niche fans who came to her through gardening, cooking, or crafts and then went on to discover the varied depths of a remarkably broad and prolific output of work.

Although the exhibition in Williamsburg had been enormously successful, from Tasha's viewpoint it had increased her popularity to a point where she had come to feel uncomfortable. From

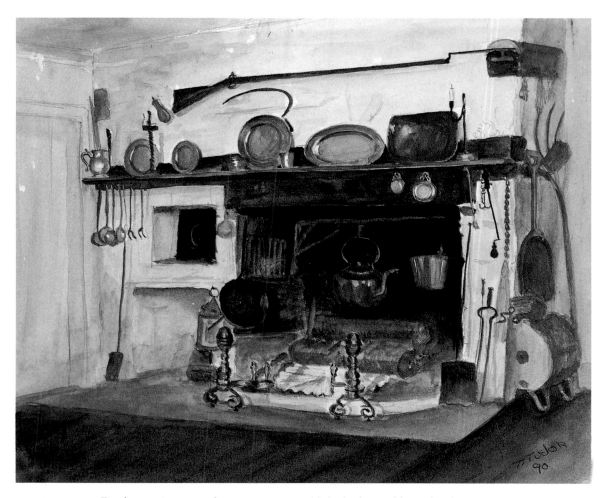

Fireplace in New Hampshire, ca. 1940s, unpublished. This starkly rendered painting is remarkable in its simplicity and rich detail. It presages many of the fireplace depictions Tasha would paint repeatedly, and a number of the objects that would become familiar to millions of readers are present here, including pewter, the copper tea kettle, the rush light, Tasha's great-great-grandfather's musket, and the tin kitchen, used for roasting turkey, seen at the left of the fireplace.

the earliest days of our company, Tasha had approached promotion of her work with a profound ambivilance. She wanted success and profit, but once it was achieved, she would deplore the "commercialization" by which it was made possible. She was unable to make peace with the fact that as she sold more books and products, there would be, inevitably, more people who wanted to know more about her.

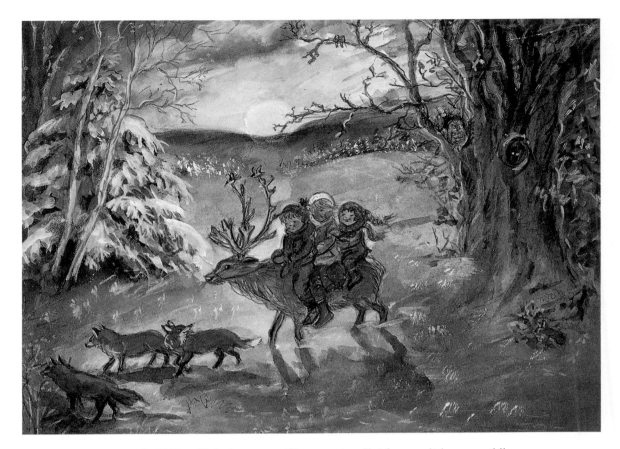

Dreamride, 1997, published as a print. The intensity of bright moonlight on newfallen snow is dramatically captured in this painting. It is evocative of the best of Tasha's imaginative depictions of her children — a midnight ride through the forest on one of the more symbolic elements of Christmas and childhood, a reindeer.

When approached by ABC-TV, we agreed to film a segment for their *Prime Time Live.* Tasha allowed a film crew to come to Corgi Cottage a day or two each month so they could show her against a backdrop of changing seasons. They made eleven visits, during which Tasha was charming and candid.

The segment aired in December of 1997. It was not what we had expected. The correspondent was somewhat fixated on death and the twilight of Tasha's long career. Wonderful scenes and delightfully forthcoming comments from Tasha did not make the editor's final cut. Nevertheless, the segment was beautifully photographed and complimentary. It proved, however, to be the undoing of our company.

Diane Sawyer, with our full permission and expectation, mentioned that this deceptively simple lady had her own Web site and gave the address. Less than an hour later, our Internet service provider had to temporarily shut down, unable to handle the demand. Within hours more than five thousand e-mail messages were received. Hundreds of them were full-page. Tasha had definitely made an impression. Some of the viewers had no previous knowledge of her or her work, but they immediately related to the person they thought she must be. They poured out their life stories and sought advice. More than

Apples, p. 126, *The Private World of Tasha Tudor,* 1992.

three hundred people wanted to help with her garden. Nine hundred letters likened her to now departed grandmothers. There were two marriage proposals.

It was a disaster. Many of the senders thought Tasha was on-line, hoping for a nice chat. The messages were sent, of course, to our office in Richmond, Virginia. One of the duties of our company was to act as a buffer for Tasha and help maintain her privacy. I had answered most of Tasha's fan mail for several years. Even the letters that made it to Tasha's home address were sent to me. Only if she so chose did she completely read a letter and answer it personally. To answer even a small number of them would have taken all her time.

I did want her to know how deeply she had touched the hearts of so many people. I foolishly took copies of more than eleven thousand e-mail messages to her at Corgi Cottage. After only the briefest inspection, she made me take them back out to my car.

Teapot, dedication page, *The Tasha Tudor Cookbook,* 1993. This painting of Tasha's favorite soft-paste teapot, one that she uses daily, is her favorite of all the paintings in her cookbook.

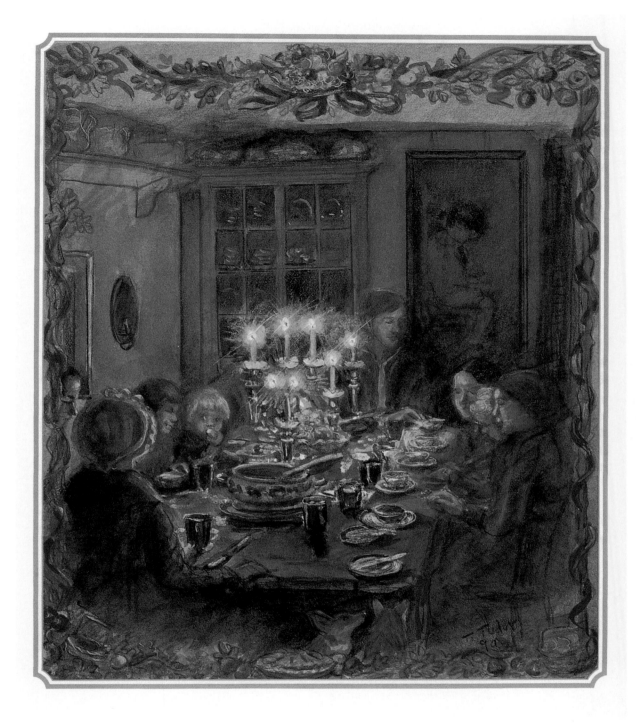

Christmas Dinner at Corgi Cottage, p. 103, *The Tasha Tudor Cookbook,* 1993.

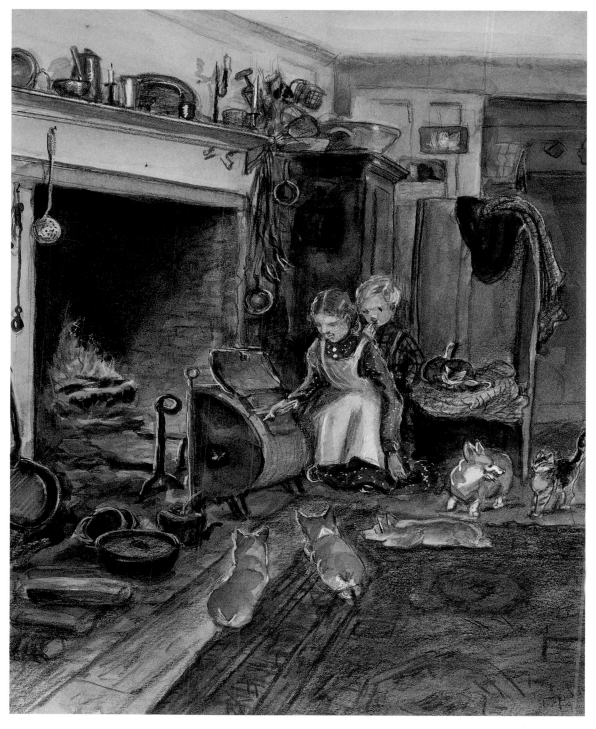

Tasha's Hearth, p. 46, *The Tasha Tudor Cookbook*, 1993.

Tasha's Garden Path, 1993, published as a print.

We began to be besieged by requests to see Tasha's garden, to have her lecture, and to appear on television. While Tasha accepted some of the offers, she was unaccustomed to the demands of a world that lives at a much faster pace than the one she had worked so hard to create. We continued our work together, but Tasha was never again comfortable with our efforts. Each new success made her feel more vulnerable. She refused an appearance on one of the most popular talk shows in the country. A major product endorsement utilizing television commercials and print ads had to be turned down.

Tasha felt overly commercialized and compromised. She was also weary. She had achieved a success far beyond anything she had ever thought possible. There didn't seem to be any challenges left for her artistically, and after the difficulties she had encountered in producing *The Great Corgiville Kidnapping*, I felt that she was reluctant to continue painting. The challenge to consistently improve had been the driving force behind the prolific body of work she had created. "I've really done everything," she said one day with a combination of bewilderment and resignation in her voice. I knew our time together had come to an end.

She faced one final contractual commitment — the creation of a third edition of *The Night Before Christmas*. She refused to work on it until she could think of some way to make it different from the other two versions she had painted. She was determined that it not detract from her reputation or her legacy. She succeeded admirably.

In the winter of an extraordinary life and career, she wishes most for her private world to become just that. She enveloped the world of this last *Night Before Christmas* in the solitude and sense of magic she wishes to envelop herself in, finally and completely.

Once more, she painted Corgi Cottage safely isolated by deep snow, its interior warm and rich with the familiar acquisitions of a lifetime. Saint Nick has become almost spritelike and definitely otherworldly. The darkness in these paintings has become friendly and inviting, allowing all the expected Tudor magic and whimsy to illuminate the rooms.

White Flowers in Blue and White Bowl,
published as a card.

The Night Before Christmas, 1999. Tasha delights in painting Corgi Cottage in deep snow because this is one of her favorite times of the year. The lack of outdoor chores gives more of a timeless quality to her days in winter, and the isolation of her farm affords her a privacy she values highly.

The Night Before Christmas, 1999. The deep snow and long icicles pictured here are not an artist's imagination at work. Normal snow accumulation at Corgi Cottage is about three feet and can last many months. Icicles frequently are several feet long and form a treacherous frame to the roofline.

The Night Before Christmas, 1999. In Tasha's final version of this classic poem, Saint
Nick has evolved into a distinctly otherworldly sprite, surrounded by sparks of light
that announce his arrival.

For perhaps the last time, Tasha painted the world as she saw it, and the vision is original, compelling, and highly satisfying. The vision is certainly not of our time, and philosophically, neither is Tasha. She is tired of the pressures of a modern world she neither understands nor respects. She has always been convinced that she had lived a previous life in the 1830s and that she had arrived in this life with all the memories and skills of that former life intact.

Since childhood, Tasha has worked long and hard to create her version of what life had been like in the 1830s. It is an authentic and personal creation or, in her mind, re-creation of what she imagines that presumably more gentle time to have been like, authentic down to the original creation she herself had to become in order to inhabit it. Although she has been strong enough to overcome all obstacles and has, in the process, become enviably successful, and although she is imaginative enough to create that other world she so admires, she hasn't been able to share it without giving it up.

The choice became a clear one for Tasha. Art had long imitated life for her, reflecting it, enhancing it, and giving her a means by which to examine and refine it. Life is, in the end, more important than art. It is to be lived and savored. In the most extraordinary accomplishment of her accomplished life to date, Tasha has become the living embodiment of that art.

Minou Asleep on Quilts, title page, *Tasha Tudor's Heirloom Crafts,* 1995.

BIBLIOGRAPHY

Titles are arranged chronologically by date of publication.

Pumpkin Moonshine. Written and illustrated by Tasha Tudor. New York: Oxford University Press, 1938.

Alexander the Gander. Written and illustrated by Tasha Tudor. New York: Oxford University Press, 1939.

The County Fair. Written and illustrated by Tasha Tudor. New York: Oxford University Press, 1940.

Snow Before Christmas. Written and illustrated by Tasha Tudor. New York: Oxford University Press, 1941.

A Tale for Easter. Written and illustrated by Tasha Tudor. New York: Oxford University Press, 1941.

Dorcas Porkus. Written and illustrated by Tasha Tudor. New York: Oxford University Press, 1942.

The White Goose. Written and illustrated by Tasha Tudor. New York: Oxford University Press, 1943.

Mother Goose. Written and illustrated by Tasha Tudor. New York: Oxford University Press, 1944.

Fairy Tales from Hans Christian Andersen by Hans Christian Andersen. Illustrated by Tasha Tudor. New York: Oxford University Press, 1945.

Linsey Woolsey. Written and illustrated by Tasha Tudor. New York: Oxford University Press, 1946.

A Child's Garden of Verses by Robert Louis Stevenson. Illustrated by Tasha Tudor. New York: Oxford University Press, 1947.

Jackanapes by Juliet Ewing. Illustrated by Tasha Tudor. New York: Oxford University Press, 1948.

Thistly B. Written and illustrated by Tasha Tudor. New York: Oxford University Press, 1949.

The Dolls' Christmas. Written and illustrated by Tasha Tudor. New York: Oxford University Press, 1950.

Amanda and the Bear. Written and illustrated by Tasha Tudor. New York: Oxford University Press, 1951.

First Prayers. Illustrated by Tasha Tudor. New York: Oxford University Press, 1952.

Edgar Allen Crow. Written and illustrated by Tasha Tudor. New York: Oxford University Press, 1953.

A Is for Annabelle. Written and illustrated by Tasha Tudor. New York: Oxford University Press, 1954.

Biggety Bantam by T. L. McCready Jr. Illustrated by Tasha Tudor. New York: Ariel, 1954.

First Graces. Illustrated by Tasha Tudor. New York: Oxford University Press, 1955.

Pekin White by T. L. McCready Jr. Illustrated by Tasha Tudor. New York: Ariel, 1955.

Mr. Stubbs by T. L. McCready Jr. Illustrated by Tasha Tudor. New York: Ariel, 1956.

1 Is One. Written and illustrated by Tasha Tudor. New York: Oxford University Press, 1956.

Around the Year. Written and illustrated by Tasha Tudor. New York: Oxford University Press, 1957.

And It Was So. Illustrated by Tasha Tudor. Philadelphia: Westminster Press, 1958.

Increase Rabbit by T. L. McCready Jr. Illustrated by Tasha Tudor. New York: Ariel, 1958.

Adventures of a Beagle by T. L. McCready Jr. Illustrated by Tasha Tudor. New York: Ariel, 1959.

The Lord Will Love Thee. Illustrated by Tasha Tudor. Philadelphia: Westminster Press, 1959.

Becky's Birthday. Written and illustrated by Tasha Tudor. New York: Viking, 1960.

My Brimful Book. Illustrated by Tasha Tudor, Margot Austin, and Wesley Dennis. New York: Platt & Munk, 1960.

Becky's Christmas. Written and illustrated by Tasha Tudor. New York: Viking, 1961.

The Tasha Tudor Book of Fairy Tales. Illustrated by Tasha Tudor. New York: Platt & Munk, 1961.

The Dolls' House by Rumer Godden. Illustrated by Tasha Tudor. New York: Viking, 1962.

The Night Before Christmas by Clement C. Moore. Illustrated by Tasha Tudor. Worcester, Mass.: St. Onge, 1962.

The Secret Garden by Frances Hodgson Burnett. Illustrated by Tasha Tudor. Philadelphia: Lippincott, 1962.

A Little Princess by Frances Hodgson Burnett. Illustrated by Tasha Tudor. Philadelphia: Lippincott, 1963.

A Round Dozen by Louisa May Alcott. Illustrated by Tasha Tudor. New York: Viking, 1963.

Wings from the Wind. Illustrated by Tasha Tudor. Philadelphia: Lippincott, 1964.

Tasha Tudor's Favorite Stories. Illustrated by Tasha Tudor. Philadelphia: Lippincott, 1965.

The Twenty-Third Psalm. Illustrated by Tasha Tudor. Worcester, Mass.: St. Onge, 1965.

First Delights. Illustrated by Tasha Tudor. New York: Platt & Munk, 1966.

Take Joy! The Tasha Tudor Christmas Book. Selected, edited, and illustrated by Tasha Tudor. New York: World, 1966.

Wind in the Willows by Kenneth Grahame. Illustrated by Tasha Tudor. New York: World, 1966.

First Poems of Childhood. Illustrated by Tasha Tudor. New York: Platt & Munk, 1967.

More Prayers. Illustrated by Tasha Tudor. New York: Henry Z. Walck, 1967.

The Real Diary of a Real Boy by Henry A. Shute. Illustrated by Tasha Tudor. Peterborough, N.H.: Noone House, 1967.

Brite and Fair by Henry A. Shute. Illustrated by Tasha Tudor. Peterborough, N.H.: Noone House, 1968.

The New England Butt'ry Shelf Cookbook by Mary Campbell. Illustrated by Tasha Tudor. New York: World, 1968.

Little Women by Louisa May Alcott. Illustrated by Tasha Tudor. New York: World, 1968.

The New England Butt'ry Shelf Almanac by Mary Campbell. Illustrated by Tasha Tudor. New York: World, 1970.

Betty Crocker's Kitchen Gardens by Mary Campbell. Illustrated by Tasha Tudor. New York: Universal Publishing, 1971.

Corgiville Fair. Written and illustrated by Tasha Tudor. New York: Thomas Y. Crowell, 1971.

The Night Before Christmas by Clement C. Moore. Illustrated by Tasha Tudor. Chicago: Rand McNally, 1975.

The Christmas Cat by Efner Tudor Holmes. Illustrated by Tasha Tudor. New York: Thomas Y. Crowell, 1976.

Amy's Goose by Efner Tudor Holmes. Illustrated by Tasha Tudor. New York: Thomas Y. Crowell, 1977.

A Time to Keep. Written and illustrated by Tasha Tudor. Chicago: Rand McNally, 1977.

The Tasha Tudor Bedtime Book. Illustrated by Tasha Tudor. New York: Platt & Munk, 1977.

Tasha Tudor's Sampler. Written and illustrated by Tasha Tudor. New York: David McKay, 1977.

Carrie's Gift by Efner Tudor Holmes. Illustrated by Tasha Tudor. New York: Collins & World, 1978.

Tasha Tudor's Favorite Christmas Carols. Illustrated by Tasha Tudor and Linda Allen. New York: David McKay, 1978.

Tasha Tudor's Five Senses. Written and illustrated by Tasha Tudor. New York: Platt & Munk, 1978.

Tasha Tudor's Old-Fashioned Gifts. Written and illustrated by Tasha Tudor and Linda Allen. New York: David McKay, 1979.

Drawn From New England by Bethany Tudor. Illustrated by Tasha Tudor. New York: Collins & World, 1979.

A Book of Christmas. Written and illustrated by Tasha Tudor. New York: Collins & World, 1979.

Springs of Joy. Illustrated by Tasha Tudor. Chicago: Rand McNally, 1979.

The Lord Is My Shepherd. Illustrated by Tasha Tudor. New York: Philomel, 1980.

The Illustrated Treasury of Humor for Children. Illustrated by Tasha Tudor and others. New York: Grosset and Dunlap, 1980.

Rosemary for Remembrance. Written and illustrated by Tasha Tudor. New York: Philomel, 1981.

A Child's Garden of Verses by Robert Louis Stevenson. Illustrated by Tasha Tudor. Chicago: Rand McNally, 1981.

The Platt & Munk Treasury of Stories for Children. Illustrated by Tasha Tudor and others. New York: Platt & Munk, 1981.

Tasha Tudor's Treasures. Illustrated by Tasha Tudor. New York: Henry Z. Walck, 1982.

A Basket of Herbs. Illustrated by Tasha Tudor. Brattleboro, Vt.: Stephen Green, 1983.

All for Love. Illustrated by Tasha Tudor. New York: Philomel, 1984.

Seasons of Delight: A Year on an Old-Fashioned Farm. Written and illustrated by Tasha Tudor. New York: Philomel, 1986.

Give Us This Day. Illustrated by Tasha Tudor. New York: Philomel, 1987.

Tasha Tudor's Advent Calendar. Written and illustrated by Tasha Tudor. New York: Philomel, 1988.

Tasha Tudor Sketchbook. Written and illustrated by Tasha Tudor. Mooresville, Ind.: Jenny Wren Press, 1989.

Tasha Tudor Miniature Gift Set. Illustrated by Tasha Tudor. New York: Philomel, 1989.

A Brighter Garden. Selected poems by Emily Dickinson. Illustrated by Tasha Tudor. New York: Philomel, 1990.

The Real Pretend by Joan Donaldson. Illustrated by Tasha Tudor. New York: Checkerboard Press, 1992.

The Private World of Tasha Tudor. Written and illustrated by Tasha Tudor. Photographs by Richard Brown. Boston: Little, Brown and Company, 1992.

Tasha Tudor's Cookbook. Written and illustrated by Tasha Tudor. Boston: Little, Brown and Company, 1993.

Tasha Tudor's Garden by Tovah Martin. Illustrated by Tasha Tudor. Photographs by Richard Brown. Boston: Houghton Mifflin, 1994.

Tasha Tudor's Heirloom Crafts by Tovah Martin. Illustrated by Tasha Tudor. Photographs by Richard Brown. Boston: Houghton Mifflin, 1995.

The Tasha Tudor Sketchbook Series: Family and Friends. Written and illustrated by Tasha Tudor. Richmond, Va.: Corgi Cottage Industries, 1995.

The Great Corgiville Kidnapping. Written and illustrated by Tasha Tudor. Boston: Little, Brown and Company, 1997.

The Night Before Christmas by Clement C. Moore. Illustrated by Tasha Tudor. Boston: Little, Brown and Company, 1999.

Tasha Tudor's Dollhouse: A Lifetime in Miniature by Harry Davis. Photographs by Jay Paul. Boston: Little, Brown and Company, 1999.

Forever Christmas by Harry Davis. Illustrated by Tasha Tudor. Photographs by Jay Paul. Boston: Little, Brown and Company, 2000.